THE
DAYTON
FLIGHT FACTORY

THE
DAYTON

FLIGHT FACTORY

The Wright Brothers &
the Birth of Aviation

TIMOTHY R. GAFFNEY

THE
History
PRESS

Published by The History Press
Charleston, SC 29403
www.historypress.net

Copyright © 2014 by Timothy R. Gaffney
All rights reserved

Front and back covers: Historical photos courtesy Wright State University Special Collections
and Archives. Wright "B" Flyer photo by the author.

First published 2014

Manufactured in the United States

ISBN 978.1.62619.356.7

Library of Congress Cataloging-in-Publication Data

Gaffney, Timothy R.
The Dayton flight factory : the Wright brothers and the birth of aviation / Timothy R.
Gaffney.
pages cm
Includes bibliographical references and index.
ISBN 978-1-62619-356-7 (paperback)
1. Airplane factories--Ohio--Dayton--History--20th century. 2. Aeronautics--Ohio-
-Dayton--History--20th century. 3. Wright Company--History. 4. Wright, Wilbur,
1867-1912--Homes and haunts--Ohio--Dayton. 5. Wright, Orville, 1871-1948--Homes
and haunts--Ohio--Dayton. 6. Dayton (Ohio)--History--20th century. 7. Dayton (Ohio)--
Biography. I. Title.
TL522.O3G34 2014
338.7'6291333430977173--dc23
2014015887

To River

CONTENTS

ACKNOWLEDGEMENTS

This book is a story about the Wright brothers and the world-changing work they did in Dayton, Ohio. Many excellent books about the Wright brothers already exist, such as Tom D. Crouch's comprehensive and wonderfully written *The Bishop's Boys*. This book tells the story with a tighter focus on what Wilbur and Orville did in and around Dayton and the places you can visit today to learn more about them and Dayton as they knew it.

Dayton is lucky to have many people who care about the story of the Wright brothers and want to share it with the pubic. Dawne Dewey, head of Wright State University Special Collections and Archives, and John L. Armstrong, Wright State archive/reference manager, gave valuable assistance in researching pictures and documents from the university's incredible collection of Wright family materials.

Wright "B" Flyer volunteer pilot Tom Walters took me up in Wright "B" Flyer Inc.'s one-of-a-kind lookalike of a 1911 Wright Model B and helped me wrap my head around certain aeronautical concepts. The whole Wright "B" team, all volunteers, deserves thanks for maintaining, operating and supporting a machine that offers riders the wind-in-your-hair experience of pioneer flight.

Edward J. Roach, historian at Dayton Aviation Heritage National Historical Park, aided my research by sharing his not-yet-published manuscript for *The Wright Company: From Invention to Industry*, the first book to focus on the Wright brothers' company.

Nancy Horlacher, local history specialist for Dayton Metro Library and the friendly staff in the library's magazine and local history rooms helped me track down a wide variety of historical materials—even searching other libraries' collections to find them.

Tony Sculimbrene, executive director of the National Aviation Heritage Alliance (NAHA), recruited me to be NAHA's communications director just as the project to preserve and restore the historic Wright Company factory site was taking off. Brad White, principal at Hull & Associates, graciously gave NAHA nearly unlimited access to the site. Wandering through the now-empty buildings, straining to hear the echoes of men and women building Wright airplanes and digging into the factory's history is what inspired me to write this book.

Introduction

Inside the chain-link fence that surrounded the site of General Motors Corp.'s Inland Manufacturing Division in Dayton, Ohio, a pair of long, low, brick buildings stood in near anonymity for decades. Massive manufacturing buildings surrounded the smaller structures on the fifty-four-acre site, blocking them from view. The two buildings were active facilities at what later became known as the Inland, Delco and finally Delphi Home Avenue plant, where for decades auto workers turned out parts and components for GM and the global auto industry. Few Daytonians remembered or ever knew how all that industry and all those jobs grew from these two modest buildings. Still, subtle architectural touches—white-painted brick instead of concrete; rows of large, arched windows along the sides; gracefully arched parapets at each end—set these buildings apart and hinted at an earlier history.

And what a history it is: not simply the nucleus of a major auto parts plant, these buildings were the birthplace of America's aerospace industry. They were the Wright Company's factory, built in 1910 and 1911 to mass-produce the flying machine invented by Wilbur and Orville Wright—the first purpose-built airplane factory in America, according to the National Park Service. The men and women who earned their livings inside these buildings were the spiritual ancestors of today's American aerospace workers.

At this writing, nearly all other structures on the old Delphi site are gone, exposing the Wright Company buildings to public view. NAHA is working with the National Park Service and municipal, state and private partners to

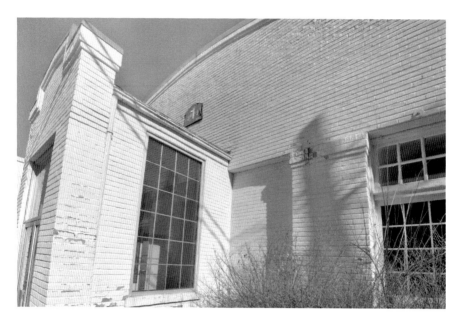

The first Wright Company factory building in 2013. *Courtesy of the National Aviation Heritage Area.*

preserve the buildings as a unit of the Dayton Aviation Heritage National Historical Park. The Wright Company factory buildings complete the story of the Wright brothers' invention, development and commercialization of the airplane.

1
At Home in Dayton

A few blocks west of the Great Miami River in Dayton, Ohio, a short walk up South Williams Street can take you more than a century back in time.

Clapboard houses facing the brick street look much as they did at the turn of the twentieth century. The sign over the storefront of the brick building at 22 South Williams bears the name "Wright Cycle Co." You can see bicycles and a sales counter through the window. Ahead, the brick façade of the Hoover Block commercial building leads to the corner at West Third Street. More than a century ago, this one-block stretch of Williams was the path Wilbur and Orville Wright walked between their home at 7 Hawthorn Street and their places of business along this two-block stretch of West Third—including, from 1895 to 1897, the shop on South Williams. On this sidewalk, in this restored neighborhood, their presence is almost palpable.

The land west of the Great Miami was mainly farmland in the 1860s. The river tended to isolate the area from the main part of town. Even after Dayton annexed it in 1868, residents called it "Miami City" for many years. By the time the Wright family moved there, west Dayton was becoming what historian Tom D. Crouch and others call a "streetcar suburb." The Dayton Street Railroad Company, formed in 1869, laid Dayton's first streetcar line on West Third Street, connecting the city from east to west. The line was more to spur land development than to make money with fares. William P. Huffman, the company's president, owned land along East Third. Vice-president H.S. Williams owned land west of the river. Land that Williams sold

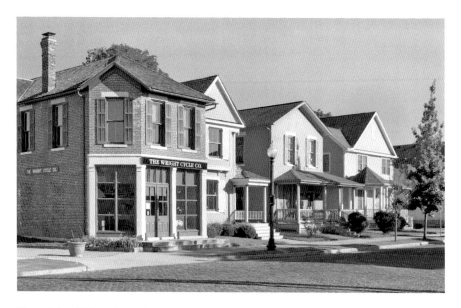

The original Wright Cycle Co. shop at 22 South Williams Street is one of many restored properties in the Wright brothers' neighborhood. *Author's photo.*

for residential development included the lot at 7 Hawthorn. A homebuilder was still finishing the house there when Milton Wright bought it in 1870.

Milton Wright was a man of superior intellect, unshakable faith and outspoken convictions—qualities that would ensure a lively and often stormy career as a leader in his church. Born in Rush County, Indiana, on November 17, 1828, Milton became a member of the United Brethren Church's White River conference in 1853. He served as a missionary in Oregon and principal of Sublimity College, the first United Brethren school on the Pacific coast. He returned to Indiana in 1859 and married Susan Catherine Koerner.

Milton's church work kept him and his family on the move. He and Susan were living in a log house on a farm in Grant County, Indiana, when Reuchlin was born in 1861. Lorin followed a year later. The Wrights had moved to a farm near Millville, Indiana, when Wilbur was born on April 16, 1867.

In 1869, Milton's election as editor of the church's official newspaper, the *Religious Telescope*, prompted him to pull up stakes once again and move his family to Dayton, home to the United Brethren Publishing House. The family lived in rented homes at first. In February 1870, Susan gave birth to twins, Otis and Ida, who died shortly after being born. The Wright family moved

into 7 Hawthorn in December 1870; Orville was born there on August 19, 1871, and Katharine followed three years later, sharing Orville's birthday.[1]

The family moved yet again in June 1878 as Milton's church business took him to Cedar Rapids, Iowa, for three years and then Richmond, Indiana, for another three. They returned to Dayton in 1884 and resumed their life at 7 Hawthorn.

Milton steadfastly opposed all forms of inequality, including slavery and secret societies—two issues that would cleave the church into quarreling factions and plunge him into controversy. The Liberals favored changing the church's

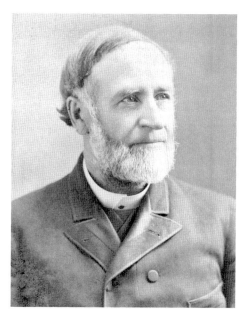

Portrait of Bishop Milton Wright. *Courtesy of Special Collections and Archives, Wright State University.*

constitution to soften its opposition to secret societies such as the Masons, whose popularity was growing across America; the Radicals opposed making concessions in their faith. Milton stood with the Radicals.

The split began in 1869 and grew for two decades until the church broke into two groups—the Radicals' Old Constitution and the Liberals' New Constitution. Each considered the other to be the breakaway group. The *Religious Telescope* reflected the views of the Liberal faction in the church. The Radical faction began publishing its own journal, the *Christian Conservator*, in July 1885. Orville later found work printing the *Conservator*.

That same year, Milton won election as bishop of the Pacific Coast district. The May 27, 1885 issue of the *Dayton Daily Journal* reported that some liberals said they only elected Milton to send him away where he wouldn't disturb them. Over the next four years, the bishop spent half his time on the West Coast.[2]

The election came at great personal cost to Milton. It was a time when his younger children were growing up and Susan was in failing health. But the bishop's travels and the family's closeness generated a constant stream of correspondence that would document much of what we know about the Wright family.

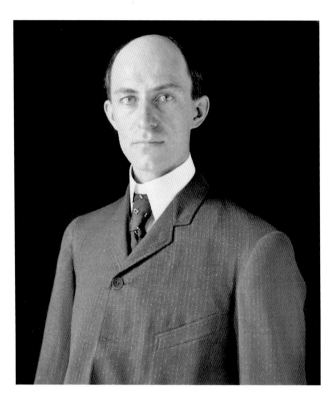

Wilbur Wright, age thirty-eight, about 1905. *Papers of Wilbur and Orville Wright, Prints and Photographs Division, Library of Congress.*

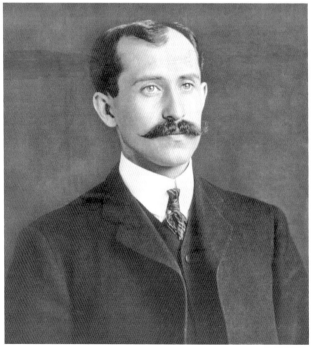

Orville Wright, age thirty-four. *Papers of Wilbur and Orville Wright, Prints and Photographs Division, Library of Congress.*

As they grew into young manhood, Wilbur and Orville shared many similarities. Wilbur stood five feet, ten inches and weighed around 140 pounds; Orville was slightly shorter and heavier. Both had gray-blue eyes and high-pitched voices. Both followed their parents' morals, eschewing alcohol and tobacco.

Family members would remember Wilbur as quiet and thoughtful. "When he had something on his mind, he could cut himself off from everyone. At times he was unaware of what was going on around him," his niece Ivonette Wright Miller recalled in later years. Orville she remembered as "a dreamer and idealist, quick to see why things didn't work and full of ideas as to how he could improve their efficiency." Wilbur paid no attention to his own appearance, while Orville was fussy about his looks. "I don't believe there ever was a man who could do the work he [Orville] did in all kinds of dirt, oil and grime and come out of it looking immaculate," she recalled in *Wright Reminiscences*, a collection of family memoirs.

Katharine was the bishop's dutiful daughter, but Milton encouraged her to earn a college degree and pursue a professional career. She graduated from Central High in 1892 and enrolled at Oberlin Preparatory School in 1893, earning a degree in 1898. She returned home to become a teacher at Central High and later Steele High School.

Lorin also remained in the bishop's orbit. He settled in Dayton, marrying Ivonette Stokes, his childhood sweetheart, and raising four children. He often provided an extra hand when Wilbur and Orville needed help with their aviation experiments. Frequently dropping in at their bicycle shop or 7 Hawthorn, Lorin's children would gain lifelong memories of their doting, ingenious uncles.

Had the Wright brothers not invented the airplane, Orville's claim to fame might have been as Paul Laurence Dunbar's first publisher. Later

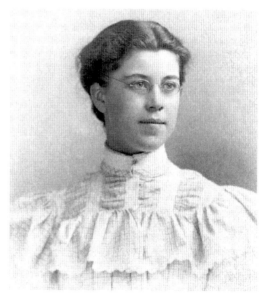

Katharine Wright at about age sixteen. *Courtesy of Special Collections and Archives, Wright State University.*

to become a renowned African American poet, Dunbar, born in Dayton on June 27, 1872, lived in the neighborhood and attended Central High, the only African American in his class. Orville recalled in later years that he and Dunbar were "close friends in our school days and in the years immediately following." Between Dunbar's poetry and Orville's printing, they shared a passion for the written word. Orville published some of Dunbar's early poetry in his newspaper, the *West Side News*. In 1890, when Dunbar decided to produce the *Tattler*, a newspaper for West Dayton's African Americans, Orville printed it for him. At some point, Dunbar scribbled a verse in chalk on the wall of Orville's print shop:

> *Orville Wright is out of sight*
> *In the printing business.*
> *No other mind is half so bright*
> *As his'n is.*[3]

The paper wasn't successful, and Dunbar soon folded it. His fame would come later, but he lived a short life, succumbing to tuberculosis on February 9, 1906, at the young age of thirty-three. The Paul Laurence Dunbar Home,

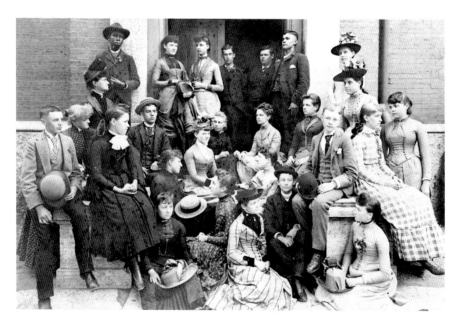

Central High School class of 1890 with Orville Wright (center rear) and Paul Laurence Dunbar (left rear). *Courtesy of Special Collections and Archives, Wright State University.*

where he lived with his mother, is now a state memorial and a unit of the Dayton Aviation Heritage National Historical Park.[4]

The Wright brothers showed uncommon mechanical aptitude, a gift usually credited to their mother. Milton was a scholar and a writer who stocked the family home with classic literature and books about science and history. Both parents encouraged their children to be inquisitive and inventive, even if that meant occasional misadventures. As Orville later told his biographer Fred C. Kelly for his book *The Wright Brothers*, "We were lucky enough to grow up in a home environment where there was always much encouragement to children to pursue intellectual interests; to investigate whatever aroused our curiosity. In a different kind of environment our curiosity might have been nipped long before it could have borne fruit."

After the Wright family's time in Iowa and Indiana, Orville returned to Dayton with a budding interest in woodcuts and printing. He renewed contact with an old neighborhood friend, Ed Sines, and discovered they

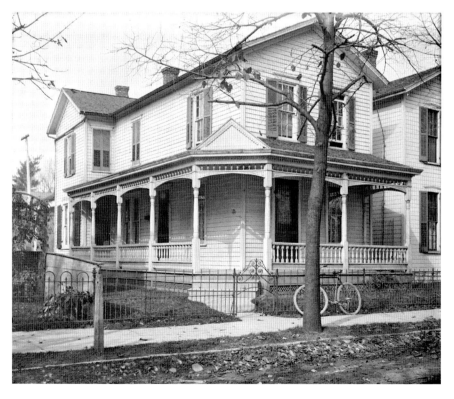

The Wright family lived at 7 Hawthorn Street from 1871 to 1914. Wilbur and Orville added the porch. *Papers of Wilbur and Orville Wright, Prints and Photographs Division, Library of Congress.*

shared a common interest. Ed had a toy-like press that could print only one line of type at a time, but the two boys formed Sines and Wright Printing in a corner of the Sineses's kitchen. At Milton's urging, Wilbur and Lorin traded an old boat they had made for a small printing press and gave it to Orville. Milton added a set of type. The press could print pages up to three by four and one-half inches. For them, it was enough to start up a business. They printed a small paper for their eighth-grade schoolmates dubbed the *Midget* and then printed some small circulars.[5]

Orville's interest in commercial printing continued to grow. Sines and Wright relocated to the "summer kitchen" at the back of 7 Hawthorn, where the boys began printing small commercial jobs. With Wilbur's help, Orville built a press of his own design using a damaged tombstone, scrap metal and other found objects. The new press could handle sheets up to eleven by sixteen inches. He took on bigger, more difficult jobs under a new imprint, "Wright Bros: Job Printers, 7 Hawthorn Street."

Orville built a bigger press in 1888, again using cast-off hardware and materials, including the folding top of an old buggy. Wilbur helped him figure out how to design some of the moving parts. It could do commercial-grade printing, as Orville described it in a July 20, 1888 letter to their father. "Our new press is large enough to print two pages of the [*Christian*] *Conservator* at once. We can run off tracts at the rate of about 500 an hour…When we have it done, I think we can run off about 1,000 or more an hour." Publishing the voice of their father's fellow Radicals was just one way the Wright children would rally to their father's cause in the embattled church.

The press was an early example of the Wright brothers' innovative thinking. Kelly's biography of the Wright brothers recounts a visit by the pressroom foreman of a Colorado newspaper who had heard about the Wrights' one-of-a-kind machine. After inspecting the press and even lying flat on his back underneath it to watch it operate, he declared, "It works all right, but I still don't understand *why* it works." Like this press foreman, the leading thinkers in aeronautics at the time would struggle to recognize how the Wright brothers' approach to the problem of flight was different from anything that had come before.

Not yet eighteen, Orville used his homemade press to launch his own newspaper. The first issue of the weekly *West Side News* came out on March 1, 1889. Early editions carried Orville's name alone, listing him as publisher or editor. A subscription cost ten cents for ten weeks or forty cents for a year. It promised to be "a paper to be published in the interests of the people and

Looking west on West Third Street toward Broadway. The Wright brothers would recognize many of the buildings. *Author's photo.*

the business institutions of the West Side" with the hope that it would "fill the long-felt want of a West Side newspaper."

The April 13, 1889 edition reported the paper was moving to "a neat little office on Third Street near the corner of Third and Broadway, where our business will be conducted thereafter. Persons wishing to subscribe for the paper or to insert advertisements will find us in the new building at 1210 West Third Street." The move to a new office coincided with Wilbur's increasing involvement in the paper. The April 20 edition listed Orville as publisher and Wilbur as editor. Wilbur's name didn't always appear, however.

The Wright brothers' papers offer glimpses of how the West Side community was developing in the nineteenth century's closing decade. In those years, Dayton was just beginning to gain many of the amenities of a modern city. It was slow to pave its streets—abundant beds of gravel, left by ancient glaciers, offered a cheap alternative to bricks. And the porous ground was thought to serve as a natural filter, eliminating the need for sewers. Dayton didn't begin paving streets until the late 1880s, and it didn't begin installing sewer lines until the 1890s. Electric lighting first appeared in

1883, and natural gas became available in 1889. Such modern utilities were slower to appear on the west side of the river.[6]

The March 30 issue of the *West Side News* noted that electric lighting and gas heat had come to Hawthorn Street. It also made a mock protest over the impact of natural gas service on jobs supported by the need to get rid of coal ash. "We believe in protection for American labor. Natural gas will force the drivers of our ash-carts to leave the business," it declared. "Can not something be done to prevent it?"

The same column reported on a transportation breakdown of the sort that happened then: "A streetcar horse dropped dead last Friday morning, a little west of the Fifth Street bridge. The company had bought it the night before and was training it to the car. It began kicking and falling down and was tramped upon by the other horse and run over by the car. Heart trouble caused its death."

The April 20 issue reported the population west of the river was approaching ten thousand. Cement sidewalks were appearing, grocery stores were opening and local business owners formed an improvement committee. Houses were going up all around the neighborhood. Commercial buildings were rising along West Third. The October 26 issue mentioned the *West Side News* office had acquired natural gas heat.

At the same time, some conditions still reflected the pioneer era. Like Dayton's downtown streets in 1889, the west Dayton streets were unpaved. The "Local News" columns in the *West Side News* occasionally mentioned workers with horse-drawn wagons sprinkling the streets, scraping off mud and laying fresh gravel. But the lack of hard pavement meant rain could leave the horse-trodden streets a muddy, unsanitary mess. The November 9 issue declared, "If Miami City only had as much enterprise about it as it has mud, it would soon be the center of business."

The paper's columns were also sensitive to any sign that the city government was neglecting the West Side. An apparently incomplete job of scraping mud from West Third Street drew the paper's ire in its December 21 issue: "The scraper did some good but it did not get over enough ground. The West Side deserves its share of attention."

The Wright brothers also published an obituary—their mother's. After a long illness, Susan died on Thursday, July 4, 1889. Milton described her last hours poignantly in his diary: "About 4:00, I found Susan sinking, and about five awakened the family. She revived about 7:00 somewhat, but afterward continued to sink till 12:20 afternoon, when she expired, and thus went out the light of my home." The family buried her in Woodland Cemetery on Saturday, July 6.

Wilbur and Orville devoted the second page of the weekly edition dated July 3, 1889, to their mother's memory. "She was of retiring disposition, very timid and averse to making any display in public, hence her true worth and highest qualities were most thoroughly appreciated by her family and those who were most intimate with her," they wrote. "Her husband relied upon her as a counselor not only in family affairs, but also in his most important business operations, literary efforts and most responsible acts in church work."

Katharine assumed her mother's role as homemaker even while she pursued her teaching career. Her older brothers also were trying to make their ways in the world.

Wilbur and Orville made a serious effort at newspapering. In April 1890, they replaced the weekly *West Side News* with the daily *Evening Item*, declaring it a product of "The Item Publishing Company." The larger, five-column paper had a much more sophisticated look than the *West Side News*, and it came out every day but Sunday. No longer simply a neighborhood paper, its premier edition asserted, "the great object will be to give readers of the *Item* the fullest, clearest and most accurate understanding of what is happening in the world from day to day." A wire service subscription gave the paper access to more news, and the paper published national and regional stories as well as baseball scores and other content.

The Wright brothers had a good press for job printing, but it was no match for the big commercial presses of their downtown competitors. And their exhortations to support the community west of the river didn't seem to sway the public. They folded the paper after three months. "The reason can be stated in a few words: More money can be made in less work in other kinds of printing, such as job printing, etc.," they wrote in "Our Parting Word" in their final issue on July 30, 1890. Apparently they weren't selling enough advertising for a worthwhile profit, and they blamed it on a lack of support for local merchants. "The greatest difficulty we had to contend with is the fact that the people of the West Side will not believe that 'anything good can come out of Nazareth,'" they wrote.[7] They continued job printing and moved their operation into the new Hoover Block commercial building at the southeast corner of West Third and Williams.

The early 1890s saw the Wright brothers develop another new interest: bicycling. They joined a national craze triggered by a new English bicycle design called the "safety," which featured same-size wheels, a geared chain drive and air-filled tires. In 1892, Orville paid $160 for a new "safety" bike—a Columbia. Wilbur bought an Eagle at an auction for $80.[8]

The second story of the Hoover block building housed the Wright brothers' printing business for a time. *Author's photo.*

They were soon using their bicycles to explore the region. In a September 18, 1892 letter to Katharine, who was visiting a cousin in Kansas, Wilbur described an epic ride to Miamisburg by way of Centerville, two towns south of Dayton. Without the benefit of today's paved bike paths and modern, multi-speed bikes, the hilly route challenged their muscles. They set out

from home after 4:00 p.m. and didn't leave Miamisburg until nightfall. They followed faint wagon tracks in the dirt and gravel to avoid puddles and potholes, but Wilbur summed up the thirty-mile excursion as a pleasant one: "The roads were in fine shape, hard and smooth, and the air was just cool enough to be nice."

For both brothers, sport quickly turned into business as they began repairing, selling and renting bikes. It was a blossoming industry; *Williams' Dayton City Directory* for 1890–91 shows only one bicycle shop in Dayton, but nine were in business by the time Wilbur and Orville opened their Wright Cycle Exchange in 1893. Renting space at 1005 West Third, they stocked up during the winter and opened for business in the spring with the start of the bicycling season. They changed the name of their bicycle business to the Wright Cycle Co. in 1894.[9]

The first bicycle shop location later became the Gem City Ice Cream Company. The company put its name on the building's façade, and that's how it became known. In the years after the Wright Cycle Exchange occupied it, the building underwent many modifications, and most of the architecture associated with the bicycle business was lost. Its façade remained as a part of the West Third Street streetscape in 2014, but the structure was in sad shape and at risk of collapse.

The Gem City Ice Cream building at 1005 West Third Street (right) was the location of the Wright brothers' first bicycle shop. *Author's photo.*

The Wright brothers' mechanical talents served them well in the bicycle business. They brought in money by repairing bicycles when sales were slow. In a September 12, 1894 letter to his father, Wilbur described business as "fair. Selling new wheels is about done for this year, but the repairing business is good." They were also renting some bikes, he said, but apparently cash was tight. "Could you let us have about $150 for awhile?" he asked. Milton wrote back that he would.

In the same letter, Wilbur confided he had been thinking "for a number of years" about going to college, but he had not felt well enough to try it until recently. Wilbur had been such an excellent scholar in high school that Milton and Susan had thought about sending him to Yale, but a hockey accident at age eighteen led to health problems that caused him to be weak and withdrawn for several years. Instead of Yale, he had tended to his invalid mother and spent time reading deeply.

In his 1894 letter, Wilbur continued, "Intellectual effort is a pleasure to me and I think I would be better fitted for reasonable success in some of the professions than in business." He thought teaching might make a good career; while it paid less than some other professions, "the pay is sufficient to allow one to live comfortably and happily, and is less subject to uncertainties than any other profession." But he admitted he would need financial help from his father to attempt it. The bishop promised to help, but Wilbur never did enter college.

The demands of the bicycle business soon prompted the brothers to find larger quarters at 1034 West Third, where they sold and repaired a variety of bicycle models. They moved again in 1895 to 22 South Williams. The upstairs housed their printing business. In this location, just around the corner from their old store locations and a few doors down from the Hoover Block, they began making their own brands of bikes.

In 1895, the Wright brothers also briefly had a bicycle shop in downtown Dayton. Milton Wright's diary entry for Friday, May 24, mentions stopping at "Wilbur's bicycle store, 23 W. Second Street."

Wilbur and Orville weren't yet out of the newspaper business, but the trend was clear. They published a small weekly paper called *Snap-Shots at Current Events* between October 20, 1894, and January 19, 1895, and from February 29 through April 17, 1896. While the first volume identified it as a publication of Wright & Wright Job Printers, it began its second volume as a product of the Wright Cycle Co. "It will inform its readers why and where to buy bicycles and other articles, and it will also keep them posted concerning the latest happenings in the bicycle world," it promised. The

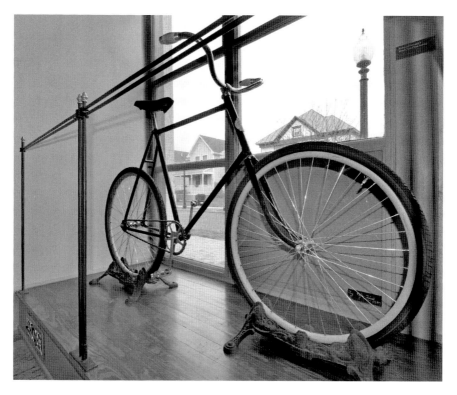

A replica Wright bicycle stands on display inside the restored Wright Cycle Co. shop at 22 South Williams Street. *Author's photo.*

second volume of *Snap-Shots* carried small ads for Wright & Wright Job Printers, but ads and editorial promotions for the Wright Cycle Co. were much more numerous.

The last issue of *Snap-Shots* announced the brothers' plans to begin manufacturing their own line of bicycles. "The Wright Special will contain nothing but high-grade material throughout, although we shall put it on the market at the exceedingly low price of $60," it boasted. "It will have large tubing, high frame, tool steel bearings, needle wire spokes, narrow tread and every feature of an up-to-date bicycle." The description matches that of their subsequently produced Van Cleve, named for a family ancestor. The Van Cleve was a top-of-the-line bike with some components of the Wright brothers' own design, including wheel hubs they claimed needed oiling only once every two years.[10]

By this time they had turned the back room of their shop into a small bicycle factory, equipped with a turret lathe, drill press and tube-cutting

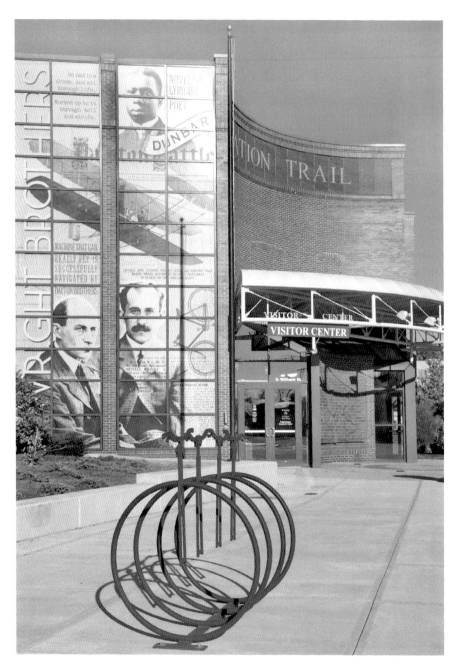

A bicycle rack on the plaza outside the Wright-Dunbar Visitor Center reflects the Wrights' bicycling legacy. *Author's photo.*

tools. Wilbur and Orville built their own single-cylinder engine to power the tools by means of a line shaft and belts. They tapped the store's gas line to fuel it. The project gave them experience in designing and manufacturing engines—expertise that would help them build an engine for their flyer.

In the fall of 1897, they relocated their bicycle and printing businesses again, to 1127 West Third. Charles Webbert had acquired an old house there and added on to it, dividing the house into two commercial spaces and adding a two-story, Italianate-style brick storefront with separate entrances and addresses. The adjacent business, at 1125 West Third, was an undertaker.

2
WINGS IN A BICYCLE SHOP

Standing in front of the wrought-iron fence at 1127 West Third Street in Dayton, all you see today is a large, grassy lot that makes a gap in a row of late nineteenth-century commercial buildings. But here is where the airplane was born. It's the site of the bicycle shop where the Wright brothers made their biggest breakthroughs in unlocking the secrets of flight. The original building, like the Wright family home at 7 Hawthorn, today stands in Henry Ford's Greenfield Village in Dearborn, Michigan. But its foundation still lies largely intact beneath the surface.[1]

This bicycle shop is the only one with a direct connection to the Wright brothers' airplane work. But if Katharine Wright's suspicion was correct in 1896, the 22 South Williams shop played an important indirect role.

In late August 1896, Orville fell seriously ill with typhoid fever and was bedridden for more than a month. Antibiotic treatments weren't available in those days, so there was little to do but keep Orville comfortable, let the disease run its course and hope for the best. Wilbur and Katharine took turns staying by his side and reading to him—as much to pass the time as to entertain Orville, who was delirious through much of September.

On August 9, famous German aviation pioneer Otto Lilienthal crashed while flying his glider, an early version of a hang glider that he controlled by shifting his weight. He died the next day. With nearly two thousand glides in a variety of designs, Lilienthal was a guiding light in aeronautics, and his death was a serious blow to the quest for flight.

The site of the Wright brothers' bicycle shop at 1127 West Third Street is preserved as a green space in the Wright-Dunbar neighborhood. *Author's photo.*

Wilbur and Orville had read about Lilienthal's work, and years later they both cited his death as the spark that ignited their desire to conquer the air. But exactly how the spark caught isn't clear. Kelly wrote in *The Wright Brothers* that both men began researching the problem of flight "after Orville was well enough to hear about Lilienthal's fatal accident." Fred Howard was skeptical in his book *Wilbur and Orville*. "It makes a nice story," he wrote, but he noted that U.S. papers had reported the accident well before Orville fell ill, so it's possible they had begun talking about it already.

Crouch's deep research for *The Bishop's Boys* convinced him that Wilbur began thinking seriously about flight years before Orville; he wrote that Wilbur "brought [his brother] up to date about Lilienthal" while Orville was recuperating in October and discussed the accident with him then.

Wilbur's own words favor Crouch's version. He later said that news of Lilienthal's death "aroused a passive interest which had existed from my childhood, and led me to take down from the shelves of our home library a book on *Animal Mechanism* by Prof. [Etienne Jules] Marey, which I had already read several times. From this I was led to read more modern works." Orville, he added, "soon became equally interested." The passage suggests Wilbur may have passed hours at Orville's bedside reading and thinking

about the subject, the passion to unlock the secrets of flight inflaming him as typhoid fever raged in his brother. Wilbur even alluded to his interest as a disease nearly four years later in the beginning of his first letter to Octave Chanute: "For some years I have been afflicted with the belief that flight is possible to man."

So how does the bicycle shop at 22 South Williams figure in it? Katharine suspected the typhoid germs came from a well at the shop. Milton didn't doubt it. "Let no one use the well water at the store henceforth," he wrote in an August 31 letter to Katharine. If they were right, the polluted well at 22 South Williams laid Orville low and bound Wilbur to his bedside for weeks with little to do but contemplate Lilienthal's death, read and think, incubating the fever for flight that eventually would afflict them both.

In later years, the Wright brothers traced their interest in aviation back to an incident in their childhood when they were living in Cedar Rapids. One evening, the bishop returned home from a trip with a novel gift for the boys: a rubber band–powered toy helicopter that flew into the air and fluttered against the ceiling. The toy fascinated eleven-year-old Wilbur and his seven-year-old brother Orville. "A toy so delicate lasted only a short time in the hands of small boys, but its memory was abiding," Orville wrote in an article under both brothers' names for the September 1908 issue of the *Century*. Wilbur made several versions of the toy, each one larger than the last.

By the close of the nineteenth century, years of spectacular and sometimes tragic failures by Lilienthal and others had convinced most people that flight was impossible. But the trail of failures made Wilbur and Orville all the more curious.

From his observations, Wilbur understood that humans couldn't match the gymnastic feats of birds darting after insects, but he saw no reason why they couldn't build machines that would allow them to move through the sky like the vultures he'd watched soaring along the Great Miami River. Had anyone disproved the idea? In 1899, he decided to find out.

"It is only a question of knowledge and skill just as in all acrobatic feats…I believe that simple flight at least is possible to man," he wrote in a May 30, 1899 letter to the Smithsonian Institution. "I am about to begin a systematic study of the subject in preparation for practical work…I wish to avail myself of all that is already known and then if possible add my mite[2] to help on the future worker who will attain final success." Assistant Secretary Richard Rathbun promptly sent Wilbur several pamphlets published by the Smithsonian and a list of other works on aeronautics. Wilbur soaked it all up.

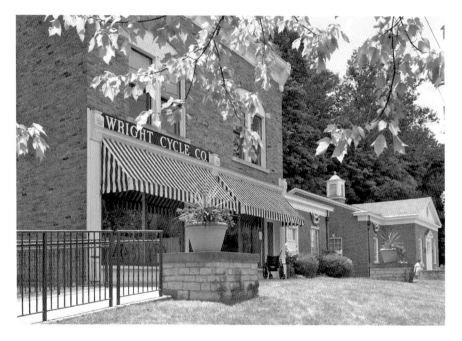

The Wright Brothers Aviation Center at Dayton History's Carillon Park includes the original Wright Flyer III and a replica bicycle shop (foreground). *Author's photo.*

An important pioneer was Sir George Cayley. The English scholar recognized that lift and thrust were separate forces that could be addressed individually, permitting the use of fixed wings and propellers. In 1799, he drew a concept for a flying machine with cambered wings, or wings with curved upper surfaces. It also had a steerable tail that functioned as rudder and elevator, propellers for thrust and a place for a pilot. He was the first to test wing shapes with a whirling arm, the forerunner of the wind tunnel.

Another pioneer was Alphonse Pénaud, a nineteenth-century French marine engineer who pioneered the concept of achieving inherent side-to-side stability in a flying machine with slightly v-shaped, or dihedral, wings and fore-and-aft stability with a horizontal elevator mounted at an angle slightly more positive than the wings. One of his most important contributions was a toy airplane he called the planophore. Its main features included a single cambered wing, a long stick for a fuselage and a tail. It popularized Cayley's concept and inspired countless young people to think about flight. A design he published in 1875 included such modern features as retractable landing gear, a control stick and a cockpit with a glass enclosure.

Louis Pierre Mouillard of France revisited soaring bird flight in his influential 1881 book *L'Empire de l'Air*. His own experiments had convinced him of the importance of using gliders to learn control before attempting powered flight.

Otto Lilienthal had a powerful influence on the Wright brothers. Like them, he was a thinker, a craftsman and an athlete. He applied his literary and laboratory research to actual experiments in gliders. Some of his glides exceeded 750 feet, farther than anyone had flown with wings. He left behind the results of his research, including a body of data on wing performance the Wright brothers would use to develop their first gliders. Historians consider his book *Der Vogelflug als Grundlage der Fliegekunst* (translated as *Bird Flight as the Basis of Aviation*) one of the classics of aeronautical literature.

Octave Chanute was a nationally known civil engineer who indulged his passion for aeronautics in his later years. He was the late nineteenth century's Wikipedia of aeronautical information—collecting, organizing and freely sharing all that had been done to date in aeronautical research. He also designed gliders, supervised experiments and collaborated with other researchers. Historian Charles H. Gibbs-Smith ranked Chanute's 1894 book *Progress in Flying Machines* second only to Lilienthal's *Vogelflug*. Chanute's double-deck wing design would strongly influence the Wright brothers in designing their own machines. The hundreds of letters he exchanged with them—mainly Wilbur—became invaluable records of their work.

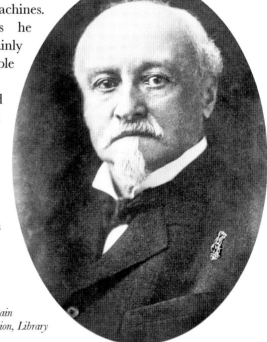

How soon Orville shared Wilbur's passion for flight isn't clear. Wilbur was always careful to share credit with his younger brother, but his letters about flight in 1899 and 1900 described his research

Octave Chanute. *George Grantham Bain Collection, Prints and Photographs Division, Library of Congress.*

as something he was doing alone. In later years, they nearly always described their work as something they did together.

That's how they later described their digestion of the scientific literature. "The larger works gave us a good understanding of the nature of the flying problem, and the difficulties in past attempts to solve it, while Mouillard and Lilienthal, the great missionaries of the flying cause, infected us with their own unquenchable enthusiasm, and transformed idle curiosity into the active zeal of workers," Orville wrote in the *Century*.

The Wright brothers found that experimenters had looked for ways to make a machine stable in flight—keeping it level from side to side and front to back. Turning received little attention; experimenters thought it merely required a rudder. One method for keeping the wings level from side to side—what experimenters called lateral stability—was to place the center of gravity well below the wings, figuring the weight would seek its lowest point. It did, but it also caused a pendulum motion. Another method was to shape the wings in a wide V, or dihedral. But this approach worked only in calm air, and any upset would cause side-to-side oscillation. A similar system was tried for front-to-back stability, with the center of gravity far forward and the tail acting as a counterbalance. But this resulted in a constant pitching motion, or undulation.

"We therefore resolved to try a fundamentally different principle. We would arrange the machine so that it would not tend to right itself," Orville wrote in the *Century*. Instead of seeking passive stability, they would pursue active control "by some suitable contrivance."

But what kind of contrivance? Lilienthal had controlled his gliders with the mass of his body, literally throwing his weight around beneath the wings to maintain stability. The Wright brothers immediately saw the flaw in this approach: weight shifting was limited by the mass of the operator, and its effectiveness would be diminished in bigger machines or stronger counterbalancing winds. "In order to meet the needs of large machines," Orville wrote, "we wished to employ some system whereby the operator could vary at will the inclination of different parts of the wings, and thus obtain from the wind forces to restore the balance which the wind itself had disturbed."

The Wright brothers' solution for lateral control was a breakthrough concept that hurtled them beyond everyone else in aeronautics. Their idea was to increase the lift of one wing and reduce the lift of the other by adjusting the angle of their wingtips relative to the wind. The wing with more lift would rise while the wing with less lift would dip. With such a

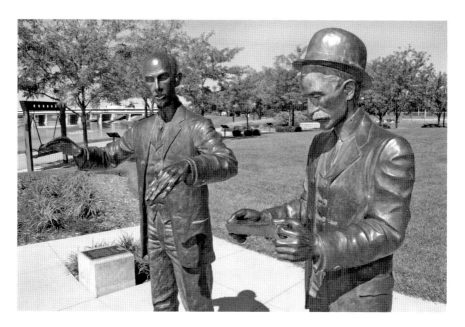

This sculpture at Deeds Point in downtown Dayton portrays Orville twisting a bicycle inner tube box as Wilbur explains his wing warping idea. *Author's photo.*

system, an operator could change the lateral balance as needed to counteract gusts. Instead of shifting his weight, an operator would simply work a control linked to both wingtips to roll the aircraft right or left. Today, pilots call it roll control.

How to manipulate the wingtips wasn't immediately obvious. At first the Wrights thought of rotating the wings in opposite directions on shafts connected by gears in the middle, but they quickly realized any device strong enough for the job would be too heavy. One day in the summer of 1899, Wilbur showed Orville how it could work. He took a cardboard box that had held bicycle inner tubes and twisted the ends in opposite directions. The upper and lower sides of the box remained parallel while the ends twisted up or down. This made it easy to imagine a stacked pair of wings, held apart by struts with flexible attachments, with a system of wires to twist the wingtips.

They quickly built a kite to test the idea. The kite featured a pair of sticks with lines connected to the front wingtips, which they could twist by working the sticks. Wilbur tested the kite while Orville was away on a camping trip and found that it worked perfectly.

Wilbur described this revolutionary idea on May 13, 1900, in his first letter to Chanute: "My observation of the flight of buzzards leads me to

believe that they regain their lateral balance, when partly overturned by a gust of wind, by a torsion of the tips of the wings. If the rear edge of the right wingtip is twisted upward and the left downward the bird becomes an animated windmill" and quickly rights itself.

Chanute would coin a term for this method of twisting the wings. He called it "wing warping." But his letters to Wilbur showed no sign that he grasped how manipulating the wingtips to change lift was fundamentally different from all previous attempts at lateral stability.

Fired with enthusiasm, Wilbur and Orville decided to build a glider that could carry one of them. But Dayton's tree-covered hills, fitful winds and hard ground didn't offer the conditions they needed for testing. They reviewed weather records and chose the Outer Banks of North Carolina, a place that offered steady wind and tall mounds of sand. The wind there, Wilbur wrote in a September 9, 1900 letter to their father from the coast, "is stronger than any place near home and almost constant so that it is not necessary to wait days or weeks for a suitable breeze." Wilbur's idea was to let the wind flowing up the dunes do the work. It would allow them to soar on an updraft over a single spot or glide downhill at low speeds relative to the ground. Either way, they wouldn't have to risk crashing into the ground at high speed.

Wilbur set out for Kitty Hawk alone on September 6 and arrived on September 11. Orville joined him seventeen days later. Wilbur's use of "I" instead of "we" in letters to their father clearly shows he thought of the project as his alone, not a collaboration. "It is my belief that flight is possible and while I am taking up the investigation for pleasure rather than profit, I think there is some slight possibility of achieving fame and fortune from it," he wrote on September 3. In a September 23 letter from Kitty Hawk, Wilbur wrote, "I have my machine nearly finished." He assured the bishop he would stay safe: "I do not intend to take dangerous chances. I have no wish to be hurt and [sic] because a fall would stop my experimenting which I would not like at all." His words suggest he didn't expect his brother to be at risk, and Orville didn't begin gliding until 1902.

The 1900 glider had wings 17 feet long and 5 feet wide with a surface area of about 165 square feet. Ahead of the wings was an elevator, which the brothers called a "front rudder." The glider's large size reflected their confidence that their wing warping system freed them from the size limits dictated by weight shifting. The results they got from it convinced them they were on the right track. The wing-warping scheme worked, and the elevator showed they could control fore-and-aft balance, or pitch. The glider itself was rugged and easy to repair.

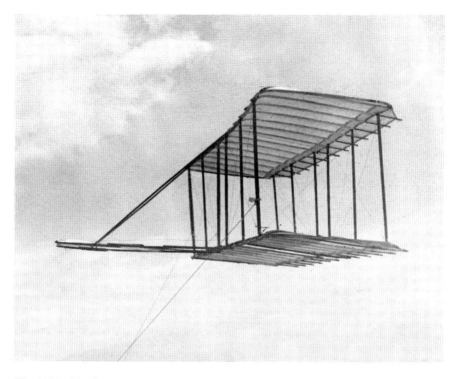

The 1900 glider flying as a kite at Kitty Hawk, North Carolina. *Papers of Wilbur and Orville Wright, Prints and Photographs Division, Library of Congress.*

Wilbur and Orville understood the basics of how a wing works. As it moves through the air, a wing's curved upper surface causes the air to flow over the top faster than under the bottom. This results in a lower pressure over the wing than under it. The greater pressure under the wing supplies the lift. Increasing the angle of the wing to the wind increases its lift. This angle between the wing and the wind is what early experimenters called the angle of incidence; today's aviators know it as the angle of attack.[3]

But there were subtle signs that flight might be trickier than it seemed. Flying the glider as a kite, the brothers measured its lift and drag and discovered both were lower than expected. It was their first hint that the data on which they had based their calculations was faulty.

They decided to return to Kitty Hawk the next year with a new glider that would allow them to experiment with their wing design. They had built it so they could easily change the camber of its wings. The 1901 glider was much bigger than the 1900 machine: each wing measured 22 by 7 feet, for a total surface area of 308 square feet. It was the biggest glider anyone had

ever tried to fly. Its wings had twice the total area of Lilienthal's glider and more than twice the area of the Chanute-Herring glider. It was another indication of their confidence in wing warping. "As the weight of the body is not moved in our plan of balancing, we think the large machine will not be much more difficult to control than a smaller one," Wilbur wrote in a May 12, 1901 letter to Chanute.

On June 15, 1901, the Wright brothers hired Charles Taylor, a skilled machinist who had done some jobs for them. Taylor lived six blocks away at Calm and Gale Streets. His wife, Henrietta, was Charles Webbert's niece.

Charlie Taylor in 1911. *Courtesy of Special Collections and Archives, Wright State University.*

They left Taylor in charge of the shop when they went to Kitty Hawk. "So far as I can figure out, Wil and Orv hired me to worry about their bicycle business so they could concentrate on their flying studies and experiments," Taylor wrote years later in an article for the December 25, 1948 issue of *Collier's Weekly* magazine.

Wilbur and Orville returned to Kitty Hawk in July 1901. Wilbur's first flights were disappointing. The glider's elevator didn't seem to control pitch as well as the 1900 glider's, and its big wings generated much less lift than they had expected. They removed the top wing and flew it as a kite to gather data. The brothers were studying not just how much lift a wing creates with different camber but also how it performs at different angles to the wind. They studied how a spot called the center of pressure moves forward and backward on the wing, affecting the wing's tendency to pitch up or down. They found the wing's camber affects how the center of pressure moves. This makes a difference in how well the elevator can control the wing's pitching. Retrussing the wings to reduce their camber solved the pitching problem.

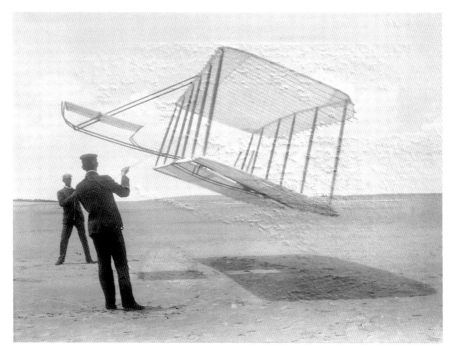

Wilbur (left) and Orville fly the 1901 glider as a kite. *Papers of Wilbur and Orville Wright, Prints and Photographs Division, Library of Congress.*

Now it was time to try a turn. The Wright brothers understood that a vertical rudder wasn't the way to turn an airplane—their 1900 and 1901 gliders didn't even have them. The secret was to tilt the wings. When an airplane is tilted to one side, not all of its lift is vertical. Part of the lifting force pushes sideways in the direction of the tilt, and the airplane dutifully turns in that direction. By using the wing warping control to tilt the glider's wings, Wilbur expected it to begin turning in a circle with the lower wings on the inside of the turn. That's how it began, but then the glider suddenly made a yawing motion in the opposite direction. Startled, Wilbur leveled the wings and landed. He tried again and the same thing happened. This unexpected response "completely upsets our theories as to the causes which produce the turning to right or left," Wilbur wrote to Chanute on August 22.

The experiments of 1901 shook their confidence in all they thought they knew about aviation—and in all the aeronautical literature they had assumed to be correct. "Having set out with absolute faith in the existing scientific data, we were driven to doubt one thing after another, till finally, after two years of experiment, we cast it all aside, and decided to rely entirely upon our own investigations," Orville wrote in the *Century*.

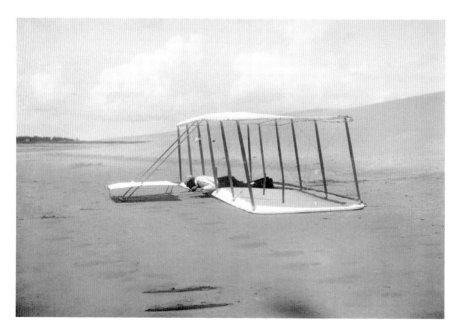

Wilbur on the 1901 glider just after landing at Kitty Hawk. Note the skid marks in the foreground and background. *Papers of Wilbur and Orville Wright, Prints and Photographs Division, Library of Congress.*

Others might have given up, but the Wright brothers took the mysteries as a challenge. "We had taken up aeronautics merely as a sport. We reluctantly entered upon the scientific side of it. But we soon found the work so fascinating that we were drawn into it deeper and deeper," Orville wrote.

One mystery was the lackluster performance of their wings. How big did a wing need to be to support a given weight in the air? What shape? How much lift and drag would it produce at different speeds? Other researchers had plowed this ground and developed formulas. Lilienthal had developed a coefficient of lift for the specific wing shape he had used on his glider and published a table of lift values for his wing at different angles of attack. Lilienthal was a highly respected pioneer. The Wright brothers relied on his work in designing their 1900 and 1901 gliders.

Now, Wilbur and Orville were suspicious. Drawing on their familiarity with bicycles, they found a clever way to test Lilienthal's data with the materials at hand. They simply mounted two plates perpendicular to the rim of a bicycle wheel and then mounted the wheel horizontally on a bicycle in front of the handlebar. One plate was curved like Lilienthal's wing; the other was flat and mounted at a ninety-degree angle to the curved one. As one of them pedaled the bike around their neighborhood, the air would flow past the curved plate and push against the flat plate. The wheel could turn freely, and it would rotate based on how much lift the curved plate generated in comparison to the force of the wind against the flat plate. With this simple instrument, they could roughly measure the lifting force at different angles of attack; according to Lilienthal's table, the two plates should balance with the curved plate at a five-degree angle of attack. Instead, it required an angle of eighteen degrees—not even close.

The bicycle rig reinforced their suspicions, but they wanted more conclusive proof. The next step was a wind tunnel. At heart, a wind tunnel is a tube with air flowing through it and a way of measuring how the air stream acts on an object mounted inside it. Others had made them. Orville built one from an old starch box not more than eighteen inches long. He set a glass plate in the top for an observation window. They used their shop engine to drive a small fan that blew air through it. Orville used the same idea of a curved plate and a flat plate mounted on a balance, but it was more precise than a bicycle wheel. They used this tunnel for only one day, but it was enough. "I am now absolutely certain that Lilienthal's table is very seriously in error," Wilbur wrote to Chanute on October 6.[4]

But why was it wrong? Was the error in Lilienthal's coefficient or somewhere else? The Wright brothers suspected a value that Lilienthal,

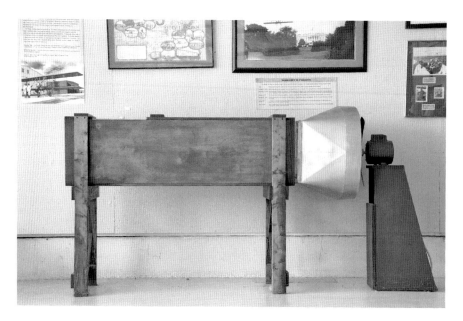

This replica of the Wright brothers' 1901 wind tunnel is on display in the hangar-museum of Wright "B" Flyer, Inc. *Author's photo.*

Chanute and others had used in their formulas for lift and drag. In the mid-1700s, British engineer John Smeaton had developed a coefficient for determining the resistance of various fluids against a flat plate. The value Smeaton came up with for air was .005, and nobody questioned it for 150 years. By the beginning of the twentieth century, however, a number of people questioned his coefficient after testing it and getting different values. The Wright brothers were aware of the debate, but they had accepted Lilienthal's judgment in sticking with Smeaton. Was it a mistake?

To find out, they took the lift measurements they had made at Kitty Hawk with their 1901 glider and worked the lift equation in reverse to find the value for Smeaton's coefficient. They repeated the exercise using data from several glides. Instead of .005, they got an average value of .0033, close to the value other researchers had found.

The precision of their crude tunnel surprised Wilbur and Orville, and the results they got from a single day of tests were "so interesting" that the brothers decided to build a more elaborate tunnel and systematically gather data on a wide range of wing shapes.

The new tunnel was an open-ended wooden box about sixteen inches on a side and six feet long. The front end had a metal shroud that directed

air through a set of crosshatched vanes to smooth the flow as it entered the tunnel. But the heart of the tunnel was its instrumentation: a pair of deceptively primitive-looking balances made from pieces of bicycle spokes and old hacksaw blades. In *Visions of a Flying Machine: The Wright Brothers and the Process of Invention*, historian Peter Jakab described them as "a mechanical representation of what the lift, and drag equations expressed mathematically." One balance measured lift and the other measured drag.

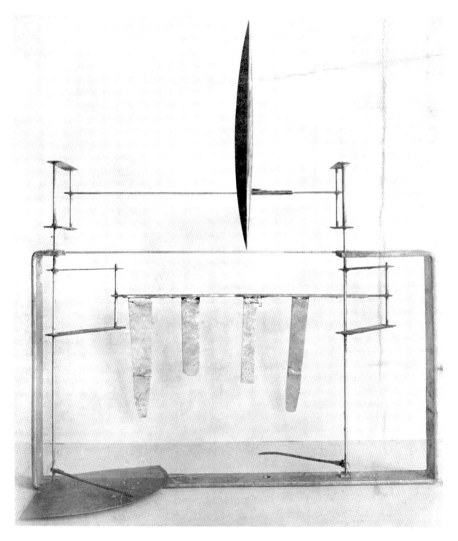

The original 1901 wind tunnel airfoil and lift balance. *Courtesy of Special Collections and Archives, Wright State University.*

Each was ingeniously simple. The lift balance, for example, mechanically measured the coefficient of lift for a given surface at a given angle of attack and showed the value on a dial.[5]

The wind tunnel turned 1127 West Third Street into an aeronautical laboratory. "It is perfectly marvelous to me how quickly you get results with your testing machine," Chanute wrote on November 18. "You are evidently better equipped to test the endless variety of curved surfaces than anybody has ever been."

Jakab and other aviation historians cite the Wright brothers' wind tunnel work as an example of their systematic approach to the problem of flight. "Of all the experimenters who preceded them, none exhibited a more refined engineering style than Wilbur and Orville Wright," Jakab wrote.

In October and early November, Wilbur and Orville ran preliminary tests on up to two hundred types of wing surfaces in various configurations. Their formal tests in late November included thirty-eight different model airfoils, some of them stacked two or three deep. The range of shapes also included airfoils of different aspect ratio—the ratio of a wing's length to its chord, or the straight distance between the front and back edges. The tests gave the Wright brothers a guide to wing design that nobody else possessed—what Fred Howard in his biography *Wilbur and Orville* deemed "some of the most remarkable trade secrets of the century."

People worldwide celebrate the Wright brothers for Orville's first powered flight at Kitty Hawk, North Carolina, on December 17, 1903. An iconic photo that captures the moment of lift off no doubt contributes to the first flight's fame. But their months of work in Dayton with the wind tunnel, painstakingly building models and recording data, was what made that moment achievable. The world, Kelly wrote, "is not fully aware of all the tedious, grueling scientific laboratory work they had to do before flight was possible."

In the following months, Wilbur and Orville tended to their bicycle business while working on a new glider to test their new data. Some airplane work went on at 7 Hawthorn. The brothers commandeered the family sewing machine to make the new glider's surfaces. "Will [as Katharine spelled Wilbur's nickname] spins the sewing machine around by the hour while Orv squats around marking the places to sew," Katharine wrote to their father on August 20, 1902. "There is no place in the house to live but I'll be lonesome enough by this time next week and wish that I could have some of their racket around," she added.

The next Wright machine was distinctly different from their previous gliders. The wings spanned thirty-two feet and measured five feet from

front to back. Their total surface area was no greater than the 1901 glider's, but their aspect ratio was about double. The new wing shape reflected the brothers' wind tunnel work and their new understanding of the importance of aspect ratio in wing design. The 1902 glider also sported a tail boom with twin vertical fins for more directional stability. To a modern aviator's eyes, it was the first Wright glider that looked like an airplane. Jakab called it "truly a thing of beauty."

The bicycle business and the airplane work weren't all that kept the Wright brothers busy during the spring and summer months of 1902. What Wilbur cryptically called "the church matter" demanded his time.

Back in 1889, the split between the Liberal and Radical factions of Bishop Wright's church had left the Dayton publishing house, and nearly all other church property, in the hands of the New Constitution group. Bishop Wright, as publishing agent, had demanded they turn it over to his Old Constitution group. The Liberals had refused and filed for title to the property, which turned the dispute into a legal battle. The case dragged on for six years, when the Ohio Supreme Court finally decided in favor of the Liberals. In the meantime, Milton and his publications board built a new publishing arm in rented space in Dayton. Its main publication was the *Christian Conservator*.

But controversy grew even within the Radicals' ranks. While the ongoing clashes between the factions kept Milton on the road, he grew suspicious that his successor as the elected publishing agent, Millard F. Keiter, was falsifying the publishing house's financial records back in Dayton. Wilbur went over the books himself and found discrepancies. "We think there is something rotten somewhere," he wrote to Milton on June 2, 1897. "He is either a liar, a thief, or an incompetent book keeper, or all three," he added.

The publishing operation moved to Huntington, Indiana, that year, but the bishop remained suspicious. In 1901, the publishing board hired an accountant to audit the books; he reported funds were missing. The questions about Keiter's accounting became a major issue at the church's general conference that year, and Keiter wasn't reelected. The auditor's final report to the publishing board found an apparent shortage of $1,470. The controversy divided the publishing board, which met in Huntington from February 11 through February 14, 1902, before voting four to three to declare Keiter's records correct.

Outraged at the apparent effort to sweep the affair under the rug, Milton launched a pamphlet campaign against Keiter. "Wilbur felt duty bound to give some help to his father," Kelly wrote in his book *Miracle at Kitty Hawk*. Wilbur pored over the financial records and wrote a "blistering tract" for his father,

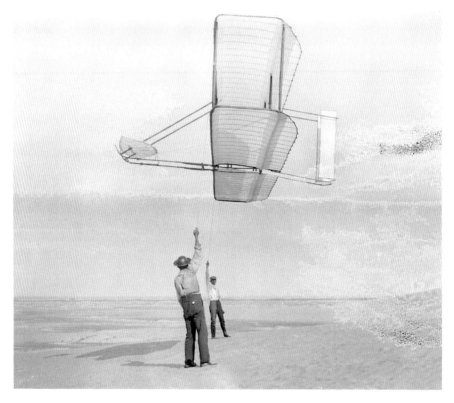

Side view of Dan Tate (left) and Wilbur flying the 1902 glider as a kite. *Papers of Wilbur and Orville Wright, Prints and Photographs Division, Library of Congress.*

one of several angry pamphlets the bishop distributed. The church controversy would continue until Milton eventually triumphed—and retired—in 1905.[6]

But in July 1902, Wilbur felt torn between his duty to his father and his passion to fly. He wrote to Chanute on July 17 that the "church matter" might delay the brothers' plans to return to Kitty Hawk. Even as they finished the glider, Wilbur wavered. "They are talking of going next Monday—though sometimes Will thinks he would like to stay and see what happens at Huntington next week," Katharine wrote to Milton on August 20.

"They really ought to get away for awhile," she added. "Will is thin and nervous and so is Orv. They will be all right when they get down in the sand where the salt breezes blow etc. They insist that, if you aren't well enough to stay out on your trip, you must come down with them. They think that life at Kitty Hawk cures all ills, you know."

The brothers returned to Kitty Hawk and spent the next several days restoring their old camp and building a new shed before assembling the glider. They finally carried it out to the smallest of the Kill Devil Hills for tests on September 19. They flew it as a kite first—an efficient way to gather basic data without risking their necks—then made about twenty-five glides. They made the first glides with the wing warping control locked so they could focus on mastering the new elevator and a redesigned elevator control.

Encouraged by the results, on September 23 they carried the glider to a one-hundred-foot-tall sand dune known as Big Kill Devil Hill for more ambitious tests. This was the first time since they had begun going to Kitty Hawk that Orville made untethered flights. On his third or fourth flight, Orville noticed the wings on one side rising. He tried to correct it by warping the wings to level them. Instead, the wings tipped higher. As Orville struggled to level the wings, he didn't notice that the glider also was pitching up steeply. On the ground, Wilbur and Dan Tate, a local fisherman who often stopped by to help, watched it angling upward and shouted warnings, but the wind drowned their voices. The machine abruptly started sliding backward toward its low wing and plunged about twenty-five feet to the ground.

"The result was a heap of flying machine, cloth and sticks in a heap, with me in the center without a bruise or a scratch," Orville wrote in his diary. The crash damaged their machine, and they knew the repairs would halt their flying for a few days. "In spite of this sad fact, we are tonight in a hilarious mood as a result of the encouraging performance of the machine," Orville wrote.

It was the only serious damage the 1902 glider sustained. The warping wing design made the wings inherently flexible, but the Wrights also made the glider with crashes in mind. "It was built to withstand hard usage, and in nearly a thousand glides was injured but once," Wilbur wrote in "Experiments and Observations in Soaring Flight," a lecture printed in the August 1903 issue of the *Journal of the Western Society of Engineers*. They also tried to keep their flights close to the ground, often gliding for hundreds of feet while just a few feet or inches above the sand.

The Wright brothers had developed the concept of lateral control in Dayton, but only actual flying could reveal its true complexity. Kitty Hawk's steady winds made it possible to fly at slow speeds over the ground, and the soft sand cushioned rough landings. These conditions allowed them to make hundreds of glides in 1902 without killing themselves. Glide by glide, they began learning how to fly.

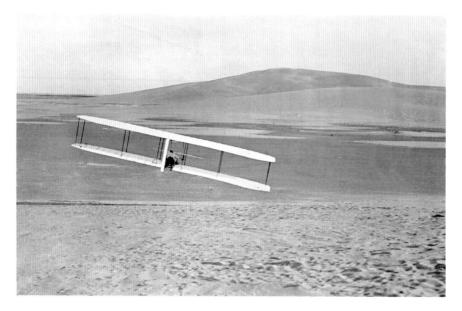

The 1902 glider was the world's first controllable airplane. Here Wilbur makes a right turn. *Papers of Wilbur and Orville Wright, Prints and Photographs Division, Library of Congress.*

The biggest puzzle they encountered was something they called "well-digging." When a shift in the wind tipped the glider to one side, it would begin to slip sideways toward the low wings. This put more pressure on the down-facing side of the tail fin and caused it to swing the glider around the low wings. This slowed the low wings and accelerated the high ones, increasing their lift and causing them to tip up even more. If the pilot warped the wings to raise the low ones, the increased drag on the low wings did more to slow them than to raise them. The result was a corkscrewing motion that ended with the glider's lowest wingtip digging a crater in the sand.

They had added the tail fins to solve the strange yawing motion Wilbur had experienced the previous year. Instead of solving the problem, the tail fin "made the machine absolutely dangerous," Orville wrote in the *Century*. Was there any solution?

It came to Orville on the night of October 2 as he lay sleepless in one of the bunks they'd mounted just under the rafters: they needed to turn the fixed tailfin into a rudder. In a well-digging situation, the operator could turn the rudder to relieve the pressure on the low-wing side and increase pressure on the high-wing side, helping to rebalance the forces. Historians say it isn't clear exactly how the brothers came up with this solution, but Orville noted

the idea in his diary the next day. Eventually, they removed one of the two fins and made the other one adjustable. "After the adjustable rudder was installed not once did we encounter the difficulty we had experienced with the fixed vane," Wilbur said later.[7]

The rudder was also what they needed to solve the yawing problem. Just as Wilbur had figured, the glider started to turn when he tilted it by warping the wings to increase the lift on one side and reduce it on the other. But the wings with more lift also had more drag. This slowed the higher wings, forcing the glider's nose to swing away from the direction of the turn. This strange behavior is what pilots today call adverse yaw. What Orville discovered was that an airplane did need a rudder—not to make a turn but to coordinate it. The rudder allowed Wilbur and Orville to balance the opposing forces of lift and drag in a turn. With a rudder, the 1902 Wright glider became the first machine truly capable of controlled flight.[8]

The success of the 1902 glider convinced the Wright brothers they were ready to build a powered machine. They returned to Dayton on October 31, and by the end of the year, they were testing propellers and working on an engine.

After all the work of figuring out how to design wings, they assumed designing a propeller—really just a rotating wing—would be a small detail. They would only need to apply their tables to the formulas marine engineers used to design marine screws—or so they thought. They discovered marine

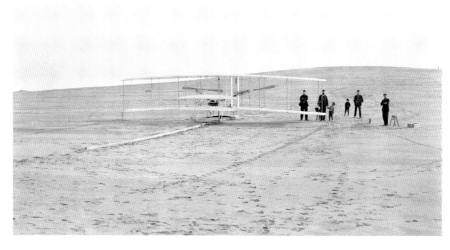

The 1903 flyer prior to Wilbur's flight attempt on December 14. The group includes four men from the Kill Devil Hills Lifesaving Station, two small boys and a dog. *Papers of Wilbur and Orville Wright, Prints and Photographs Division, Library of Congress.*

engineers had no theory for marine screw performance that could help them predict propeller performance. They would either have to work by trial and error or come up with their own theory. As Orville wrote in the *Century*:

> *What at first seemed a simple problem became more complex the longer we studied it. With the machine moving forward, the air flying backward, the propellers turning sidewise, and nothing standing still, it seemed impossible to find a starting-point from which to trace the various simultaneous reactions. Contemplation of it was confusing. After long arguments, we often found ourselves in the ludicrous position of each having been converted to the other's side, with no more agreement than when the discussion began.*[9]

Wilbur and Orville persevered, eventually developing propellers that were much more efficient than any earlier designs. But they still lacked an engine to turn them. They needed one that could deliver eight or nine horsepower and weigh no more than 180 pounds. They couldn't find any commercial engines that met their needs, so they directed Taylor to make one.

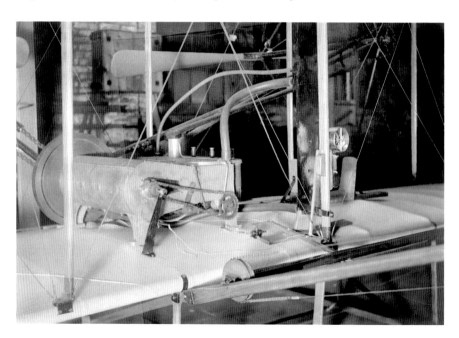

Front view of the 1903 Wright Flyer motor. *Courtesy of Special Collections and Archives, Wright State University.*

"We didn't make any drawings. One of us would sketch out the part we were talking about on a piece of scratch paper and I'd spike the sketch over my bench," Taylor wrote in his *Collier's Weekly* article. "It took me six weeks to make that engine. The only metal-working machines we had were a lathe and a drill press, run by belts from the stationary gas engine."

Taylor made the crankshaft by tracing the outline on a block of machine steel, drilling holes along the outline with the drill press and then chiseling off the excess hunks of metal like a sculptor. He put the rough part in a lathe and turned it down to the correct size and smoothness. "It weighed nineteen pounds finished and she balanced up perfectly, too," he boasted in his article.

A local foundry made castings for the aluminum crankcase and iron cylinder barrels, pistons and rings. Taylor bored cylinder holes in the crankcase with the lathe. The 1903 engine didn't use spark plugs but what Taylor called "make or break" electrical contact points inside the combustion chamber that were operated by shafts and cams geared to the main camshaft. A battery was connected to the engine for starting, but once started, a magneto supplied the spark and the battery was removed. Fuel flowed by gravity from a one-gallon fuel tank mounted on a wing strut. Instead of mixing with air in a carburetor, the fuel flowed into a shallow chamber in the manifold next to the cylinders, where the heat quickly vaporized it. They started the engine by priming each cylinder with a few drops of gasoline. Cooling water circulated through thin jackets around the cylinders to a radiator.

They tested the new engine for the first time on February 12, but the engine body and frame broke the next day in another test. They ordered a new casting and had the new engine running by May.

The 1903 Wright Flyer reflected its bicycle-shop roots. Its drive system used chains and sprocket wheels to turn the twin propellers. The single-rail launching track also reflected bicycle locomotion. The track was a series of wooden beams, set on edge and capped with a metal strip. The flyer rode down the track on a truck, essentially a wooden platform on a pair of inline rollers. The rollers were modified bicycle hubs; enlarged flanges straddled the track, acting as guides.

While they made the parts for the 1903 Flyer in Dayton, they didn't fully assemble it there because the bicycle shop was too small. Waiting until they were on the Outer Banks to assemble and ground-run the machine took extra time and effort. They learned the hard way that the propeller shafts

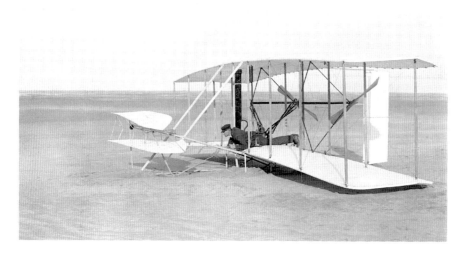

Wilbur in the damaged 1903 Flyer, moments after his unsuccessful flight attempt on December 14, 1917. *Courtesy of Special Collections and Archives, Wright State University.*

were too weak. One broke during a power test on November 5. Wilbur and Orville shipped the shaft back to Taylor for repair, but it broke again on November 28. Orville had to return to Dayton to assist Taylor in building new ones. He left Dayton with new shafts on December 9 and arrived back in Kitty Hawk on December 11.

They set up the track on the slope of Big Kill Devil Hill on December 14. They tossed a coin to see who would make the first flight attempt. Wilbur won. The flyer took off, but it stalled after three and a half seconds and settled to the ground 105 feet downhill from its takeoff point. They didn't count it as a flight. They tried again on December 17, this time on flat ground. Now it was Orville's turn.

Orville described the historic flight without emotion in his diary:

> *On slipping the rope the machine started off increasing in speed to probably 7 or 8 miles. The machine lifted from the truck just as it was entering on the fourth rail. Mr. Daniels took a picture just as it left the tracks. I found the control of the front rudder quite difficult on account of its being balanced too near the center and thus had a tendency to turn itself when started so that the rudder was turned too far on one side and then too far on the other. As a result the machine would rise suddenly to about 10 ft. and then as suddenly, on turning the rudder, dart for the ground. A sudden dart when out about 100 feet from the end of the tracks ended the flight.[10]*

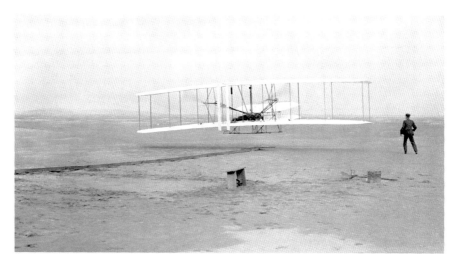

John T. Daniels's iconic photo of Orville Wright making the first powered flight on December 17, 1903. *Courtesy of Special Collections and Archives, Wright State University.*

The flight covered 120 feet in twelve seconds, but given a 45-foot-per-second headwind, Orville calculated the flight was equivalent to 540 feet in calm air. "The flight lasted only 12 seconds," Kelly wrote in *The Wright Brothers*, "but it was nevertheless the first in the history of the world in which a machine carrying a man had raised itself by its own power into the air in full flight, had sailed forward without reduction of speed, and had finally landed at a point as high as that from which it started."

Orville sent a telegram from the lifesaving station at Kitty Hawk to their father back in Dayton, relayed through a telegraph office in Norfolk, Virginia. The Norfolk telegraph operator—against Orville's instructions—leaked it to a reporter at the *Norfolk Virginian-Pilot*. Most journalists had little understanding of flight. Some had heard of the powered blimp the Brazilian Alberto Santos-Dumont was flying to great acclaim in France. But the notion that wings could lift a flying machine was often beyond their grasp. The Norfolk reporter invented grossly inaccurate details to explain the flight, such as a six-bladed propeller mounted under the aircraft to push it up. The newspaper splashed the story across its front page and offered it to others; a few papers across the country reprinted it, including the *Dayton Herald*.

But the widespread belief that the Dayton press ignored or badly misrepresented the facts is false. The December 18 *Dayton Journal* and

the evening edition of the *Dayton Daily News* got nearly all the facts right. Their identical wording suggests they used a press release from the Wright family. "The Wright Flyer is a true flying machine. It has no gas bag or balloon attachments of any kind, but is supported by a pair of aero-curves or wings," both papers reported. They continued, "The machine is driven by a pair of aerial screw propellers placed just behind the main wings. The power is supplied by a gasoline engine designed and built by the Messrs. Wright in their own shop."

The *Daily News* noted that earlier reports based on the dispatch from Norfolk were inaccurate. But the magnitude of the achievement was lost on the copyeditor who wrote the headline: "Dayton boys emulate great Santos-Dumont."

This wasn't even the first time the Dayton papers reported on the Wright brothers' work. The Saturday magazine section of the January 25, 1902 *Daily News* reprinted Wilbur's 1901 lecture to the Western Society of Engineers, accompanied by illustrations derived from photos of their glider experiments.

The brothers soon heard from Augustus Herring, another experimenter who had worked with Chanute. Herring had visited their Kitty Hawk camp with Chanute in 1902. Herring claimed he had independently found a solution to powered flight and suggested forming a partnership with the Wright brothers that would include a one-third interest for him. He also claimed to be the originator of Chanute's biplane glider and said he had been offered money for his rights to interference suits against the Wrights. They ignored his letter.[11]

The public and newspaper editors greeted word of the Wright brothers' achievement with a mixture of indifference, skepticism and utter confusion. No wonder; the list of people who had attacked the problem and failed read like a who's who of famous inventors, from Leonardo da Vinci to Thomas Edison. Nine years earlier, machine-gun inventor Hiram Maxim's four-ton, steam-powered beast had struggled to rise a few inches from its railroad-like track before crashing. Lilienthal, of course, had died. Most recent was Samuel Pierpont Langley's tandem-wing *Aerodrome*, funded by $50,000 of taxpayer money under an army contract. His spectacular failure had come just as the Wright brothers were achieving success. On October 7 and again on December 8 in 1903, Langley had tried to catapult the gangly contraption from a boat in the Potomac River with assistant Charles Manly at the controls. Each

time, the *Aerodrome* had folded up and dropped into the water. Renowned astronomer and mathematician Simon Newcomb said attempting to fly was like "squaring the circle." The press ridiculed Langley for even trying.[12]

3

ON HUFFMAN PRAIRIE

Eight miles east of Dayton in Greene County, Wright-Patterson Air Force Base is a sprawling, 8,100-acre campus of research laboratories, acquisition centers, a graduate-level engineering college, a foreign intelligence center, the U.S. Air Force's national museum and an active airfield. The huge base is fenced and guarded, but some areas are open to the public. How did all this come to be here?

To find out, drive along the narrow Symmes Road through thin woods on a public part of the base until you come to a small clearing. In it stands an open-air platform, made of unpainted wood with rough handrails under a flat, angled roof. Behind it, inside the fence, lies the airfield—home over the years to flying machines ranging from primitive biplanes to nuclear-armed B-52 bombers. In the opposite direction, across Symmes Road, lies a wide, mowed pasture. On the far side of it stands a long shed and a tower, both made of wood. None of this is what you would expect to see on an air force base. The pasture is known today as the Huffman Prairie Flying Field. It's a National Historic Landmark and a unit of the Dayton Aviation Heritage National Historical Park. The shed and the tower are replicas of the structures the Wright brothers built to test their flying machines after 1903. The platform is a replica of Simms Station, a trolley stop along the Dayton, Springfield and Urbana (DS&U) Electric Railway. Wright-Patterson's history began here in 1904, when a DS&U trolley squealed to a stop at the station and Wilbur and Orville Wright stepped off.

A red-tailed hawk regards Mark Dusenberry's replica 1905 Wright Flyer III from its perch atop the catapult derrick on Huffman Prairie early on October 4, 2007. *Author's photo.*

The Wright brothers started 1904 full of confidence and ambitious plans. The first week of January saw them designing a better engine, ordering new parts and tracking down a good patent attorney. They had in mind building a fleet of airplanes for exhibition, possibly at the massive centennial celebration of the Louisiana Purchase being planned in St. Louis. The aviation portion of the event promised up to $200,000 in prize money. "We are at work building three machines with which we shall probably give exhibitions at different places during the coming season. We may decide to enter one at St. Louis," Wilbur wrote to Chanute on January 18. The brothers even visited St. Louis to inspect the grounds. But the St. Louis show's organizers had set up the course and written the rules with airships in mind; they weren't conducive to airplanes, and the Wrights concluded they had little chance of winning any prize money. Even so, Wilbur entertained the idea as late as July in letters to Chanute.

They still had much to learn about how to make a practical flying machine, let alone how to fly it. But with a powered machine, at least they no longer needed to mount an expedition to Kitty Hawk in order to test an idea. All they needed was a big field free of obstructions. Torrence Huffman, president of the Fourth National Bank and a family friend, agreed to let them use Huffman Prairie, part of an old family farm then worked by tenant farmer David C. Beard.[1]

Orville knew about the site from field trips with his high school science class. The DS&U line, a part of the rapidly growing network of fast interurban railways, had begun running between Springfield and Dayton just four years earlier. The stop at Simms Station made Huffman Prairie easy to reach.

Wilbur described the prairie in a June 21, 1904 letter to Chanute:

> *We are in a large meadow of about 100 acres...In addition to cattle there have been a dozen or more horses in the pasture and as it is surrounded by barbwire fencing we have been at much trouble to get them safely away before making trials. Also the ground is an old swamp and is filled with grassy hummocks some six inches high so that it resembles a prairie-dog town.*[2]

The Wright brothers erected a Kitty Hawk–style shed on Huffman Prairie in April. By the end of the month they were assembling their next airplane: the 1904 Flyer. Like the 1903 machine, it had skids and used a launching track. Wheels were as impractical on Huffman Prairie's lumpy ground as on Kitty Hawk's sand.

The airplane was ready by the third week in May, but day after day of rain kept them grounded. They decided to try a flight on Monday, May 23,

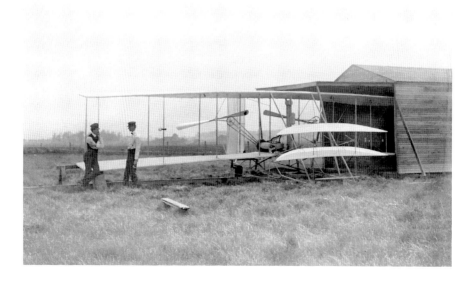

Orville (left) and Wilbur with their 1904 flyer in its shed in May 1904, at the beginning of their experiments on Huffman Prairie. *Papers of Wilbur and Orville Wright, Prints and Photographs Division, Library of Congress.*

and invited the press to come out and watch. "Our only request was that no pictures be taken, and that the reports be unsensational, so as not to attract crowds to our experiment-grounds," Orville wrote in the *Century*. About a dozen journalists turned out, including reporters from all the Dayton papers. Milton and other family members also came. Altogether, a crowd of about fifty gathered on the boggy pasture to watch the Wright brothers repeat the historic flights they'd made at Kitty Hawk.

The event was a flop—literally. The wind barely stirred, and the engine was balky. They discovered later that a spark point had worked loose and only three cylinders were firing. But the crowd was waiting expectantly, so the brothers gave it a try. "The machine, after running the length of the track, slid off the end without rising into the air at all," Orville wrote. Rain and engine trouble plagued them all week. A few reporters showed up at least once more, but the best they could manage was an unimpressive hop by Orville of twenty-five to sixty feet. Underwhelmed, the press by and large left the Wright brothers alone after that.

Their luck didn't get much better in June. Bad weather and fickle winds limited their flying opportunities, and the short flights they made often ended with hard landings and damage to the airframe. "We certainly have been 'Jonahed' this year, partly because of bad weather, partly by being compelled to use pine spars in our wings [because spruce was in short supply], which causes breakages difficult to repair quickly," Wilbur wrote to Chanute on June 14.

Weather was only part of the problem. They were still having trouble controlling the flyer on its pitch axis. Its nose bobbed up and down as it flew. Amos Root, a beekeeping supplier from Medina, apparently witnessed some of their troubled flights when he stopped in Dayton on a four-hundred-mile trip across Ohio. "When I first saw the apparatus it persisted in going up and down like the waves of the sea. Sometimes it would dig its nose in the dirt, almost in spite of the engineer," he wrote in the January 1, 1905 issue of the trade journal he published, *Gleanings in Bee Culture*. Just as Root described, on June 25 the flyer "struck the ground in one of its undulations while going at full speed, and pointed slightly downwards," Wilbur wrote to Chanute. They made only two flights in July. They spent most of their time rebuilding the airplane to move the center of gravity back and forth. They even added fifty pounds of steel bars to the front runners.

The ballast seemed to help. "It was finally cured of its foolish tricks, and was made to go like a steady old horse," Root wrote. They made nine

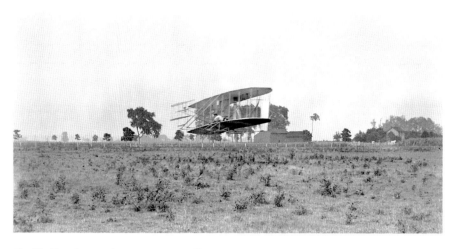

Orville flies close to the ground on Huffman Prairie in 1904. *Papers of Wilbur and Orville Wright, Prints and Photographs Division, Library of Congress.*

flights in the first six days of August, including one of six hundred feet on August 6. That flight was their best so far in 1904, but it was still short of Wilbur's longest flight at Kitty Hawk.

Their biggest problem now was getting enough speed to take off from their short track. The flyer needed about twenty-eight miles per hour to stay aloft, but it could barely reach twenty-four miles per hour before it ran out of track. This meant the flyer needed a slight headwind to get airborne; if they lost it, the flyer would drop to the ground. A longer track over that lumpy soil just wasn't practical. "It is evident that we will have to build a starting device that will render us independent of wind, and are now designing one," Wilbur wrote in an August 8 letter to Chanute.

What they came up with was a system any naval aviator today would understand: a catapult. They built a twenty-foot-tall derrick with a rope-and-pulley system that allowed them to hoist a stack of weights up to 1,400 pounds up the middle of it. Through a series of pulleys, the rope ran down to the base of the derrick, out to the end of the track and back to the flyer. A second rope attached to a stake in the ground near the pilot served as the release cable. They tried it for the first time on September 7. They found it could accelerate the flyer to twenty-eight miles per hour on sixty feet of track. This was the boost they needed. The rate and distance of their flights jumped dramatically. On September 15, they made two flights of a half-mile each, flying to the fence line and turning back.

A replica of Simms Station, where the interurban trolley stopped at Huffman Prairie, along the public entrance road to the prairie on Wright-Patterson Air Force Base. *Author's photo.*

The similarity to aircraft carrier catapults isn't coincidental. In a 1912 letter to Captain W. Irving Chambers of the U.S. Navy, Orville described their system and suggested using it to launch aircraft from navy ships.

Only five days later, Wilbur made history. It was his second flight of the day after an intermission of heavy rain. Shot off the track by the catapult, Wilbur cruised northeast across the prairie. With the north fence line approaching, he banked left and began a wide, gentle turn until he had completed a circle—the first ever flown in a heavier-than-air machine. He flew past his starting point before landing, having flown nearly one mile.

The local press wasn't around to witness the flight, but Amos Root was there. His January 1905 column was a rambling, 3,500-word essay about the Wright brothers' experiments and the whole subject of transportation, but buried near the end was an almost lyrical description of Wilbur's flight and its emotional impact on Root:

> *The engine is started and got up to speed. The machine is held until ready to start by a sort of trap to be sprung when all is ready; then with*

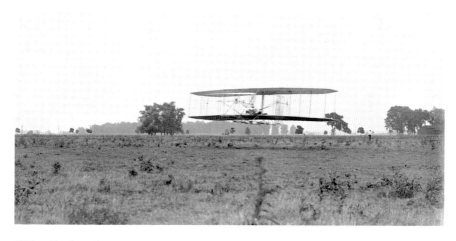

Wilbur flies just above the ground on Huffman Prairie in 1904. *Papers of Wilbur and Orville Wright, Prints and Photographs Division, Library of Congress.*

a tremendous flapping and snapping of the four-cylinder engine, the huge machine springs aloft. When it first turned that circle, and came near the starting-point, I was right in front it; and I said then, and I believe still, it was one of the grandest sights, if not the grandest sight, of my life. Imagine a locomotive that has left its track, and is climbing up in the air right toward you—a locomotive without any wheels, we will say, but with white wings instead, we will further say—a locomotive made of aluminum. Well, now, imagine this white locomotive, with wings that spread 20 feet each way, coming right toward you with a tremendous flap of its propellers, and you will have something like what I saw. The younger brother bade me move to one side for fear it might come down suddenly; but I tell you, friends, the sensation that one feels in such a crisis is something hard to describe.[3]

Wilbur and Orville had made 105 flights in 1904 by the time they closed the season on December 9. But their uneven record didn't show a pattern of steady improvement. It was an indication that they had not yet mastered their invention. Wilbur wrote in his notebook that he made "almost four rounds" of the field on November 9 in a flight that lasted five minutes, four seconds. But they still hadn't eliminated the flyer's tendency to pitch up. Even with seventy pounds of steel bars in front, they had to hold downward pressure on the elevator as they flew. More troubling, the flyer sometimes refused to obey when they tried to bring it out of a turn, forcing them to land it with its wings still banked. "The cause of the difficulty proved to be very

obscure and the season of 1904 closed without any solution of the puzzle," Wilbur wrote later.[4]

But they had committed themselves to success. They let their bicycle business languish, and they would close it the next year. Charlie Taylor spent most of his time at Huffman Prairie "as sort of airport manager at Simms Station," he wrote in *Collier's Weekly*. "I suppose it was the first airport in the country, with all due respect to the sands of Kitty Hawk."

4
THE WRIGHT FLYER III

Inside a stately brick building at Dayton History's Carillon Historical Park, a railing surrounds a sunken floor occupied by a primitive airplane with yellowed wings. On a typical day, visitors gather behind the railing to gaze down on the airplane. The name of the building is Wright Hall, and it was built for one purpose: to preserve and display the 1905 Wright Flyer III, the world's first practical airplane. It's the only airplane that's a National Historic Landmark, and it's a unit of the Dayton Aviation Heritage National Historical Park.

Unlike the stubby 1903 and '04 flyers, the 1905 machine is a sculpture of flight. Its balanced proportions and upward sweeping lines make it seem eager to fly. But its elegant design is merely a byproduct of form following function. The Wright brothers were striving for practicality, not beauty. Its pleasing lines resulted from enlarging the elevator and extending it farther ahead of the wings. Putting the elevator farther out in front slowed its response rate and made it easier to control pitch oscillations. To support the elevator, the flyer's runners were lengthened and bowed smoothly upward.

The Wright Flyer III also embodied many less noticeable changes from the earlier flyers. The Wright brothers uncoupled its rudder from the wing warping system and added a separate lever to allow them to control the rudder independently. At the same time, they added a pair of half-round vanes they called blinkers between the upper and lower surfaces of the elevator. They reused the 1904 engine, which was just getting broken in;

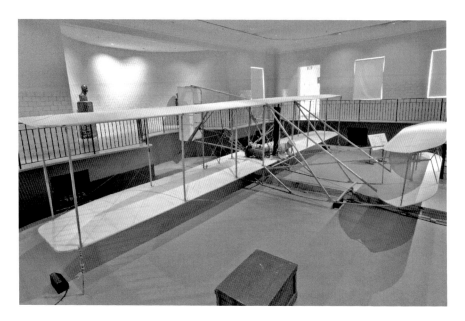

The original Wright Flyer III at Dayton History's Carillon Historical Park is also a unit of the Dayton Aviation Heritage National Historical Park. *Author's photo.*

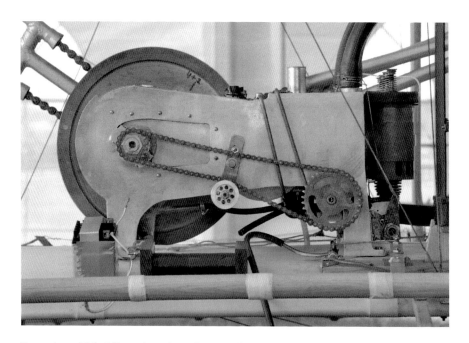

Front view of Mark Dusenberry's replica 1905 Wright motor. *Author's photo.*

tests showed it was delivering more horsepower than when it was new. But they added a fuel pump, an oil pump and a water pump.

Even before testing the 1905 machine, Wilbur and Orville were confident they had a marketable product. "We stand ready to furnish a practical machine for use in war at once, that is, a machine capable of carrying two men and fuel for a fifty-mile trip," Wilbur wrote to Chanute on May 28.

They weren't nearly ready, but they didn't know it yet. They still had one more secret to discover—one that even today claims the lives of unwary pilots.

Tests of the 1905 machine through the summer weren't much more successful than the previous year. Crashes, damage and repairs were frequent. On July 14, a flight by Orville started well, but as the flyer gained speed, it began to undulate "and suddenly turned downward and struck [the ground] at a considerable angle," Wilbur wrote in his diary. The crash snapped the top wing spars. Orville "was thrown violently out through the broken top surface but suffered no injury at all," Wilbur wrote. The spars broke in just the right places to spare him from potentially serious injury.

It could have ended much differently, as a strikingly similar crash showed more than a century later. In 2005 and 2007, Mark Dusenberry of Dennison, Ohio reenacted the Wright brothers' flights on Huffman Prairie with an

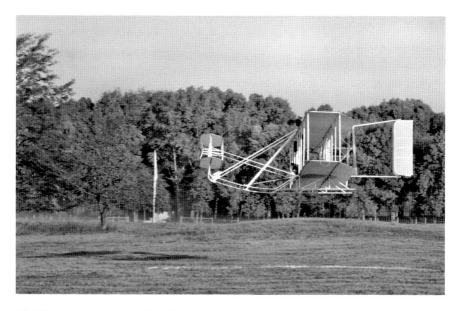

Mark Dusenberry reenacted the October 5, 1905 flight of the Wright Flyer III on Huffman Prairie in 2005 and 2007. This photo shows a successful practice flight in 2009 before a crash. *Author's photo.*

exquisite Wright Flyer III replica he had built himself. On October 1, 2009, he was making a practice flight for the third such event when the flyer began undulating and suddenly pitched down, slamming into the ground. Dusenberry suffered severe injuries and lost the use of his legs. The crash destroyed his replica. It was a sobering reminder of the danger the Wright brothers faced every time they flew.[1]

The Wright brothers tweaked the 1905 design repeatedly. They got rid of the blinkers, further enlarged the elevators and extended them farther ahead of the wings. They also enlarged the vertical rudder.

Finally, three months into the flying season, their flying improved. They stayed aloft longer and showed better control. On September 8, Orville flew the first figure eight by either brother.

On September 28, Orville learned another lesson the only way nature teaches it: by experience. He was eight minutes into a flight and was headed toward an isolated honey locust tree that marked the western edge of their course over the prairie. Orville was about ten feet higher than the forty-foot-tall tree. As he banked for a left turn, Orville noticed he was slipping toward the tree and its shaggy armor of long, sharp thorns. He tried to bank to the right to steer away from it, but the left wings refused to rise. As the tree loomed closer, Orville pushed the elevator down hard in an effort to land before he went into it.

Immediately the left wings came up and the flyer turned to the right. A wing brushed the tree with enough force to drive a thorn into a strut and rip a branch from the tree. Orville quickly turned the elevator up, and instead of slamming into the ground, the flyer just grazed it before nudging back into the air. Orville skimmed the ground until he was back at the shed, the thorny branch defiantly hanging on.

Analyzing the incident afterward, Wilbur and Orville realized what had happened. As the flyer banked into a left turn, its left wings were on the inside of the turn and were moving more slowly than the right wings. The lower, slower wing surfaces became stalled, producing little lift, so the wing warping did no good. When Orville pushed the nose down, the wings sped up, and the left surfaces became effective again. In a summary of their 1905 experiments, Wilbur described the insight gained from Orville's brush with the locust tree as their final breakthrough to practical flight: "When we had discovered the real nature of the trouble, and knew that it would always be remedied by tilting the machine forward a little, so that its flying speed would be restored, we felt that we were ready to place flying machines on the market."[2]

Orville flies about sixty feet above Huffman Prairie on September 29, 1905. *Papers of Wilbur and Orville Wright, Prints and Photographs Division, Library of Congress.*

With no handbook or instructor, the Wright brothers were lucky to survive long enough to discover the solution to this problem. Today, basic flying manuals flag it as one of the biggest hazards in the landing pattern, when the pilot is low and slow and making the final turn to line up with the runway. If the turn is too wide, the pilot may be tempted to correct it by tightening the turn. This can cause the wing on the inside of the turn to stall just as Orville's did. With the airplane slow and close to the ground, the consequences can be deadly.

Wilbur's and Orville's flights continued to get longer—nearly twenty minutes on September 29, twenty-five minutes on October 3 and more than thirty-three minutes on the fourth. On October 5, Wilbur flew for thirty-nine minutes, twenty-three seconds (Milton recorded it in his diary as thirty-eight minutes, four seconds), circling over the field for the equivalent of more than twenty-four miles. Wilbur landed only when the flyer ran out of fuel. That flight alone exceeded the total duration of all 105 flights of 1904.

Landowner Torrence Huffman and his son William were on hand to witness the historic flight. They had taken the interurban out to Simm's Station and were walking down the road toward the flyer when Beard, the tenant farmer, pulled up on a wagon loaded with corn. The Huffmans climbed onto the wagon to watch the flight. "It went round and round and

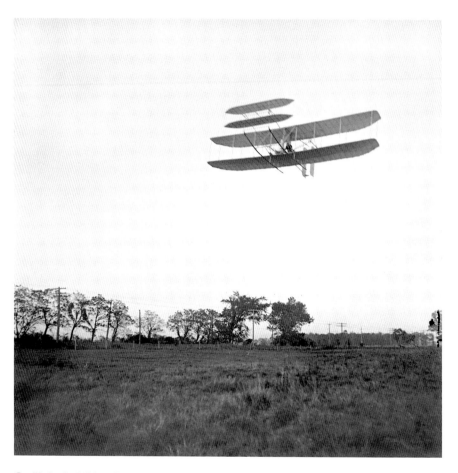

Orville in the Wright Flyer III on the last photographed flight of 1905. *Papers of Wilbur and Orville Wright, Prints and Photographs Division, Library of Congress.*

each time the plane circled the field we put a pencil mark on the floor of the wagon," William Huffman recalled in 1978.[3]

As the flights grew longer, more people heard about them, and the local press began publishing reports. The *Dayton Daily News* published an article about their October 5 flight the next day. Soon, a crowd lined the fence, some with cameras. The Wright brothers decided not to fly until the crowd went away. The rest of the world might not have heard about the Wright brothers' flights, but they were becoming common knowledge in Dayton and Greene County.

Wilbur took off again on October 16, but engine trouble forced him down after a single lap. The brothers planned to make one more flight, staying

aloft for more than an hour, and wanted Chanute to see it. He would have made an expert witness to their feat. On October 30, they wired him to ask if he could come down from Chicago to watch a flight the next day. Chanute hopped on a train, but a storm thwarted the flight and ended the flying season. The October 5 flight stood as their longest of 1905.

The Wright Flyer III was the culmination of their experiments. While they had proved flight was possible with the 1903 Flyer in Kitty Hawk, their flights in the Wright Flyer III on Huffman Prairie proved it was practical.

5
Down to Business

O n Fountain Square in Springfield, Ohio, about thirty miles northeast of the Wright brothers' bicycle shop, stands a bronze statue of a stout man, pen in hand, facing the Bushnell Building across East Main Street. The statue is that of Harry Aubrey "H.A." Toulmin Sr., a patent attorney who had his office in the Bushnell Building at the turn of the twentieth century. In 1904, Springfield was a thriving manufacturing town with plenty of business for a good patent attorney. Today, Toulmin's statue memorializes his critical role in aviation history as the man who wrote the patent application for the flying machine.

The Wright brothers didn't need lettered scientists or certified engineers to invent the airplane, but convincing the U.S. Patent Office of their achievement was another matter. They learned this the hard way when they tried writing their own patent claim.

They crafted the application in late 1902 and early 1903, basing it on their 1902 glider. (Even then, it was clear they recognized controlled flight, not powered flight, as the real breakthrough.) They made their application on March 23, 1903—nearly a year before their first powered flights.

The Patent Office, all too familiar with baseless flying machine claims, promptly rejected it. Wilbur wrote back and tried to explain that their invention actually worked. The Patent Office turned them down again, with the suggestion that they hire a skilled patent attorney.

Wilbur asked friends for the name of a good lawyer. They recommended Toulmin. On January 22, 1904, Wilbur rode the DS&U interurban out to

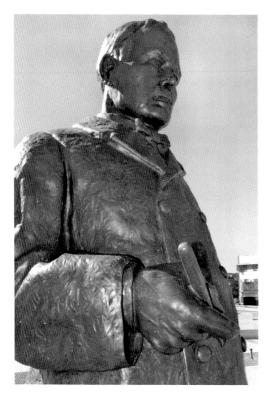

A statue of Harry Toulmin, the attorney who wrote the Wright flying machine patent, faces the building where he had his office in Springfield, Ohio. *Author's photo.*

Springfield to meet with him. Toulmin grasped the essence of their breakthrough and agreed the patent should focus on their system of control, not simply an airplane. He went to work on a patent application that would give them the broadest possible protection and withstand all court challenges.

In the meantime, the Wright brothers looked for their first customer. They hoped it would be the U.S. Army. After all, they could deliver what the army had paid Langley to develop. They met with their congressman, Robert Nevin, on January 3, 1905. He offered to forward a letter from them to William Howard Taft, secretary of war, a Cincinnati native and fellow Republican.

The letter they sent on January 18 summarized their accomplishments on Huffman Prairie and declared they now had "a flying machine of a type fitted for practical use." Two wartime applications they suggested were scouting and carrying passengers. The letter included a boast about their invention that sounds humorous today: "It not only flies through the air at high speed, but it also lands without being wrecked." But Nevin was out sick when the letter came. Instead of sending it directly to Taft, an aide forwarded it to the U.S. Army Board of Ordnance, which demonstrated its lack of interest in a reply that read like a form letter.[1]

The Wright brothers also sought a deal with the British War Department. British military officials were interested, but they wanted to see it fly before they would negotiate terms. This was a deal breaker for Wilbur and Orville, who had become cautious about disclosing their trade secrets. Until they

had a patent to protect their invention, they couldn't take the risk of public demonstration flights. They weren't asking for a penny up front; they simply required a contract that would guarantee them payment once they delivered the goods. But they faced the deeply entrenched and widely accepted belief that heavier-than-air flight was impossible. The negotiations fizzled out in December 1905.[2]

The Wright brothers had good reason to worry about protecting their trade secrets. Word of their gliding experiments had caused a seismic shift in thinking among members of the Aero Club of France. They immediately shifted their focus from ballooning to gliders. What galvanized them was none other than the Wright brothers' Chicago friend, Octave Chanute. In April 1903, the well-meaning flight evangelist visited France and gave detailed descriptions of American gliding efforts. He also wrote an article for the August issue of the Aero Club's journal, *L'Aérophile*. The article described the Wright brothers' gliding experiments and included illustrations showing basic structural details of their 1902 glider. A few European experimenters began building and testing their own machines based on the Wright design. Their inability to duplicate the Wright brothers' success fueled skepticism and outright disbelief, especially after they heard of the Wrights' 1903 powered flights.[3]

So strong was the disbelief that Aero Club members Henri Deutsch de la Meurthe and Ernest Archdeacon offered a prize worth the equivalent of $10,000 to the first person to fly a one-kilometer circle in France. Archdeacon even taunted the Wright brothers with it in a March 10, 1905 letter that noted France's "incredulity" about their claims and suggested they "come to give us lessons" in flying. By then, of course, the Wright brothers had flown circles of more than a kilometer on Huffman Prairie. But even $10,000— roughly equal to $240,000 in 2014 dollars—wasn't enough to tempt Wilbur and Orville to give up their secrets without a patent.[4]

It was a tough situation. The Wright brothers needed to protect their trade secrets, but they also needed credibility if they were to attract any customers. After wrapping up their flying in 1905, they sent letters describing their work to publications in England, France and Germany. Over the next two years, business and government representatives would approach them, only to back off before closing a deal.

Late in 1905, some French business leaders decided to form a syndicate and act on behalf of their government, which was indecisive about the Wrights' claims. The syndicate sent a representative, Arnold Fordyce, to meet with the brothers in Dayton in December 1905. Wilbur and Orville

A replica of the Wright brothers' 1904–05 flyer shed stands on Huffman Prairie. *Author's photo.*

wanted $200,000 to deliver an airplane that could fly fifty kilometers in an hour and technical data that would allow France to build airplanes of other sizes and speeds. The syndicate would deposit the money in a New York bank by April 5, 1906, to be paid to the Wrights once they had delivered the machine and demonstrated its performance. A $5,000 deposit would hold the option; after April 5, the option would expire, and the Wrights could keep the deposit. The agreement wouldn't prevent them from continuing to seek a contract with the U.S. Army.

The French War Ministry agreed to put up the money for the deposit and dispatched Fordyce back to Dayton in March 1906 with an official government delegation. Seeking to avoid public notice, they stayed in the downtown Beckel House at Third and Jefferson instead of in the newer, grander Hotel Algonquin at Third and Ludlow, where Fordyce had stayed on his first visit. A hotel telegraph operator tipped off a reporter about the foreign delegation, but Fordyce convinced the journalist that the group was only in Dayton to study its water system.

Again, the Wright brothers refused to show their airplane, but their forthright manner, photos and numerous eyewitness accounts by responsible citizens were enough to convince the delegation—especially since the brothers weren't demanding any payment until after they had demonstrated a machine that met all requirements. But ministry officials back in Paris set additional demands. It became apparent to Wilbur and Orville that the ministry really just wanted a one-year extension on its option, buying time for French experimenters to come up with a successful machine of their own.

The Wrights refused, and the negotiations collapsed. Wilbur and Orville collected the $5,000, but they hadn't sold an airplane. Similarly, another round of negotiations with the British, including a visit by a British War Department representative, went nowhere.

Compounding the frustration of dithering foreign officials was the continuing public skepticism at home. The U.S. press was picking up European reports about the Wright brothers' claims. *Scientific American* openly doubted them. Surely, it argued in a January 1906 editorial, the aggressive American press would have rooted out the news if they had really flown: "Is it possible to believe that the enterprising American reporter, who, it is well known, comes down the chimney when the door is locked in his face—even if he has to scale a fifteen-story sky-scraper to do so—would not have ascertained all about them?" Apparently, *Scientific American* didn't believe its own reporting; it had published a full-page, illustrated feature about the brothers' gliding experiments in 1902 and an article—albeit one riddled with errors—about their powered flights in December 1903. Of course, the Dayton press had publicized their flights on Huffman Prairie.[5]

Coming to the Wright brothers' defense was the new Aero Club of America. The predecessor of today's National Aeronautic Association, the club had just formed the year before. In January 1906, it held the first large American aeronautical exposition in New York. The Wright brothers furnished photos and parts from their 1903 engine for a small exhibit. After *Scientific American*'s January insult and barely a mention in a February supplement about the show, the Wright brothers detailed their flights over the previous two years on Huffman Prairie in a letter to the Aero Club. The letter included a list of seventeen eyewitnesses.

Ten days later, the club adopted a resolution congratulating Wilbur and Orville and sent it out in a press release, accompanied by the full text of their letter. *Scientific American* queried the witnesses and received eleven replies, all confirming their fellow Daytonians' claims. The magazine's editors reversed their position in an April feature story. "There is no doubt whatever that these able experimenters deserve the highest credit for having perfected the first flying machine of the heavier-than-air type which has ever flown successfully and at the same time carried a man," it stated. Suddenly regaining faith in the magazine's past reporting, the editors gave themselves credit for recognizing the Wright brothers' work four years earlier.[6]

The U.S. Patent Office finally granted their patent, No. 821,393, on May 22. France had granted a patent back in 1904. Germany granted one in July 1906. But Wilbur and Orville were still reluctant to make exhibition flights.

Holding a patent was one thing; having the means to defend it against infringement was something else. "We decided we would be absolutely lost if our patent became known before we had $200,000 to fight with," Orville said years later in a February 27, 1914 article in the *New York Times*. He said their experience in court showed their fears weren't exaggerated.

On December 1, 1906—now more than a year after they had stopped flying—the Wright brothers received a visit from Ulysses D. Eddy. He was a New York businessman who had formerly worked for Charles Ranlett Flint of Flint & Co., a well-known investment banker. Eddy wanted to negotiate a deal he could offer to Flint. Wilbur and Orville happened to be on their way to New York for the second Aero Club exhibition, so they agreed to meet with a Flint & Co. executive. Negotiations with Flint & Co. would go on for more than a year before bearing fruit.

All along, the brothers had hoped to interest the army, but officials refused to take them seriously. In early 1907, Wilbur and Orville thought of a way to get the government's attention. It was a stunt that would have been the envy of Maverick, Tom Cruise's character in the Hollywood film *Top Gun*: buzzing the U.S. Navy's Atlantic Fleet.

This copy of a newspaper photo shows Wilbur and Orville conducting hydroplane experiments on the river in Dayton in 1907. *Courtesy of Special Collections and Archives, Wright State University.*

In the spring of 1907, organizers in Virginia planned a massive celebration of the 300th anniversary of the settlement of Jamestown. The celebration would take place south of Jamestown on Sewell's Point in Norfolk, where the James River empties into the Hampton Roads. President Theodore Roosevelt would be there. So would members of Congress, the navy's Atlantic Fleet, the press and vast crowds of people. What if Wilbur and Orville staged a surprise fly-over? The sudden sight of a flying machine soaring over the fleet would steal the show, stun the country and prove beyond doubt the Wright brothers had mastered the air.

It wouldn't be easy. They figured they would need to take off from, and land on, water. They went so far as to build a small raft on pontoons and rig it with an engine and propellers. They floated it on a wide stretch of the Miami River near the Third Street Bridge, just upstream from a low dam. People lined the bridge to watch the strange, noisy contraption. It seemed to work with one person, but with two on board it tipped over and plunged into the water, damaging the propellers. Fate seemed to be conspiring against them; before they could make another attempt, the dam broke, ruining their test site. They abandoned the project, but the fact that this low-key, sometimes secretive pair would even consider such a scheme hints at how frustrated they must have been with the War Department.[7]

Fortunately for Wilbur and Orville—if not for the rubberneckers on the bridge—an alternative to the dangerous stunt soon surfaced. On May 16, Flint & Co. sent a telegram asking for one of them to join some company officials to meet their marketing representative in France, Hart O. Berg. The ship would leave New York on May 18. Wilbur hurriedly packed and jumped on a train. Orville stayed behind to finish a new flyer.

Wilbur started with low expectations. "I think there is nothing special on," he wrote Chanute from the train. But he soon found himself negotiating with French businessmen to form a company to sell airplanes to the French government.

Just as Wilbur was leaving for France, a new letter came from the War Department. Congressman Herbert Parsons of New York had read the *Scientific American* article and sent it to President Roosevelt, who had passed it to Secretary of War Taft, who had passed it to the Ordnance Board. On May 11, the board sent a letter to the Wright brothers offering to hear about their project, but its grudging tone implied to Wilbur and Orville that the board was only going through the motions to appease the White House.

Wilbur was off to France, leaving Orville to follow up with the Ordnance Board. They made a new formal proposal: for $100,000, they would deliver

one flyer and teach a pilot how to fly it. Before collecting any money, they would make a demonstration flight of fifty kilometers in no more than an hour "and land without any damage that would prevent it immediately starting upon another flight." The board responded that their asking price "would require a special appropriation" from Congress.

With Wilbur deep in negotiations in Europe and Orville dealing with the Ordnance Board while trying to finish the new flyer, they found themselves without each other's company and support in possibly the most stressful time of their lives. Adding to it was the misunderstanding and frustration that resulted from having to communicate by letter and telegram.

Things weren't going well for Wilbur. The French plan to form a company wasn't working out, and he felt Orville was making vague and unreasonable demands instead of trusting his older brother. Wilbur pressed him to finish the flyer so it could be ready to ship to Europe in case they reached a deal.

But Orville was also annoyed with Wilbur. "You have not answered a single question I have asked in my cables," he chided on July 11. He was also "completely disgusted" with what he saw as mismanagement by Flint & Co.

It didn't help that Wilbur's cables often referred to letters that hadn't come yet, causing confusion. Milton complained to him that it was "trying on Orville's nerves." Wilbur wrote an angry retort. "You people in Dayton seem to me to be very lacking in perspicacity," he said on July 20—thickheaded, in other words. By then, Wilbur had been away from home and out of his country for more than two months, and the negotiations were still fruitless. No doubt he was homesick and angry at the same time. Wilbur had tried to persuade Orville to make the trip instead of him. But Orville "happened to be in one of his peculiar spells just then, and I soon saw that he was set on finishing the machine himself," Wilbur complained to their father. He also groused that Orville wouldn't be taking so long on the airplane "if he had attended energetically to his department, and avoided interference in mine."

Orville finally got the flyer shipped and joined Wilbur on July 28. Charles Taylor left separately and joined them on August 11 in case they needed his help to assemble the flyer.

But negotiations with the French military went nowhere, and the Wright brothers finally withdrew their offers. German military officials were interested, but they refused to commit to a deal. Orville even went to England for a fruitless discussion with the receiver of the Barnum & Bailey Circus and the Buffalo Bill Wild West Show.

Wilbur returned home on November 28. They still hoped to sell airplanes in Europe, but they thought they might have to make demonstration flights

in the spring to convince their doubters. They left the flyer in its crate in France. Orville spent some extra time in Paris to arrange to have some engines built there. He finally returned home on December 13.

While still overseas, Wilbur and Orville received word from the Ordnance Board that it was considering their proposal, but it still faced the prospect of asking Congress for money. They indicated the price was negotiable if they could be assured their patents wouldn't be "palpably disregarded" by the government. "We care much more for an assurance of fair treatment than for extreme price on the first machine," they wrote from London on October 30.

This broke the logjam. The Ordnance Board drew up specifications for an army airplane based on what the Wright brothers had proposed. On his return from Europe, Wilbur stopped in Washington and met with the board. He offered a big price drop—the first flyer for $25,000 and subsequent airplanes for $10,000 apiece. Even so, the army's Signal Corps decided it needed to advertise for bids.

On January 27, Wilbur and Orville submitted a bid that promised to deliver, within 200 days, a machine that could fly two people at a speed of forty miles per hour. The bid process was a legal formality; the Wright brothers had the only machine that could meet the requirements. That didn't stop some forty other dreamers, tinkerers and fraud artists from

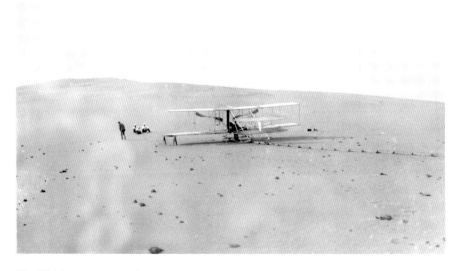

The Wrights returned to Kitty Hawk in 1908 with their modified 1905 Flyer. *Papers of Wilbur and Orville Wright, Prints and Photographs Division, Library of Congress.*

submitting bids, offering unsolicited advice or simply asking for money. But two valid bids were lower than the Wrights', and the Signal Corps felt obliged to accept the lowest bid. It resolved the dilemma by accepting all three. One immediately withdrew, leaving the Wright brothers with one competitor—Augustus Herring, whose bid claimed he could produce an airplane in 180 days for $20,000. Signal Corps officers didn't believe Herring could deliver, and he met their expectations. He had done no serious work and never produced an airplane. While the army was only looking for one airplane, Hart Berg continued to work on a bigger deal in France. Finally, he reached agreement with a new syndicate whose goal wasn't simply to stand in for the government but to set up a commercial business to make and sell Wright airplanes in France. The terms were less than Wilbur and Orville had sought the previous year; instead of $200,000 for one airplane, they would get half that amount, plus half the company's founding shares and about $4,000 apiece for the next four airplanes they delivered. But at last they had a deal. They signed.

It might be true that an army marches on its stomach, but Wilbur and Orville found it an uncomfortable way to fly. "I used to think the back of my neck would break if I endured one more turn around the field," Kelly quoted Orville as saying in *The Wright Brothers*. The flyer project that had delayed Orville's travel to Europe was an improved design that would allow two people to sit upright on seats and control the flyer with levers. The configuration would be necessary for training and for operational use such as observation. Orville found the new controls to be "a great improvement over the old system." After the first flyer, Orville built four more for demonstration flights in America and Europe. The new flyer also had a redesigned engine.

Wilbur would need to make demonstration flights in France while Orville put the military flyer through its paces at Fort Myer, Virginia. They rebuilt their experimental Wright Flyer III to test the new configuration and knock the rust off their flying skills. They added upright seats and control handles, as well as a bigger engine, radiator and fuel tank. They took it to Kitty Hawk in April 1908. Wilbur left on April 6 and Orville soon after. Charles Furnas, a Dayton mechanic interested in their work, went along as a volunteer.

As word of the army contract spread, the national press began to take a serious interest in the Wright brothers. Several publications dispatched reporters to Kitty Hawk to observe them. Lurking in nearby woods as Wilbur and Orville tested the modified flyer, the reporters witnessed the first flight of an airplane carrying two people.

Wilbur went directly from Kitty Hawk to New York in May 1908 and sailed to France. Once again, the brothers found themselves an ocean apart, each bearing major responsibilities. Both must have felt tremendous pressure.

Wilbur found strong support in Léon Bollée, an auto manufacturer, who offered space in his factory at Le Mans, about 125 miles southwest of Paris. Scouting the area for a flying field, Wilbur found Les Hunaudières racetrack. The track's owner agreed to lease it to him. Wilbur sent for the crated airplane that had been sitting in storage since the year before. He opened it to find not an airplane ready for assembly but a jumble of damaged parts and equipment. Ribs and other wooden parts were broken, fabric was torn, the radiators were mashed and engine parts were damaged. Wilbur lashed out as he had before: "I never found such evidence of idiocy in my whole life," he fumed in a letter to Orville. "Did you tell Charley [Taylor] not to separate anything lest it should get lonesome?"

Orville suspected customs agents of rooting through the flyer's crate and repacking it carelessly. Whatever the cause, undoing the damage cost Wilbur several days of hard work and compounded frustrations he was having with inept helpers.

They persevered. After years of working in the shadows while inaccurate news reports fueled skepticism and disbelief, the Wright brothers were finally ready to go public.

Wilbur flew first. On August 8, a catapult launcher like the one they had used at Huffman Prairie shot the flyer off its track before a crowd that included members of the Aero Club of France and newspaper reporters from Paris.

The flight lasted less than two minutes, but Wilbur's steady control and graceful, banked turns electrified the crowd. The French press sang the Wright brothers' praises.

Wilbur Wright at Le Mans, France, in 1908.
Courtesy of Special Collections and Archives, Wright State University.

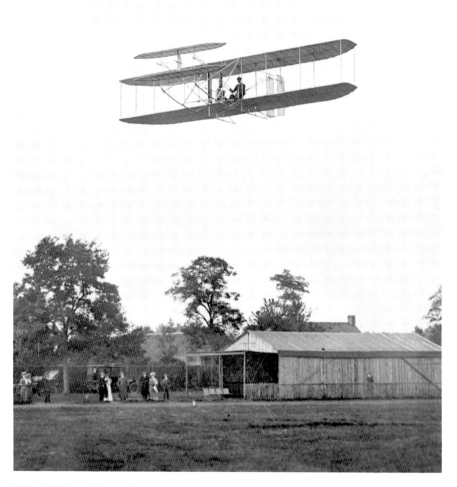

Wilbur Wright circles the field at Les Hunaudières racetrack in France. *Courtesy of Special Collections and Archives, Wright State University.*

Wilbur made nine flights at the racetrack between August 8 and August 13. In late August, at the invitation of the French army, Wilbur relocated to the larger Champ d'Auvours, a French army field about ten miles away.

While Wilbur was a sensation in Europe, his flights weren't getting prominent play in the United States. Fewer than a thousand spectators turned out for Orville's first flight attempt on September 3. Orville made a brief hop, circling the small field one and a half times and staying aloft for just over a minute. But the crowd "went crazy," Theodore Roosevelt Jr., son of the president and a witness to the event, told Kelly years later. Kelly

Orville Wright flies at Fort Myer. *George Grantham Bain Collection, Prints and Photographs Division, Library of Congress.*

quoted him in *The Wright Brothers*: "'I'll never forget the impression the sound of the crowd made on me. It was a sound of complete surprise.'" Three or four newspaper reporters who witnessed the flight approached Orville in tears.

Several thousand were on hand the next day when Orville flew for four minutes, fifteen seconds. Orville made more flights in subsequent days. On the morning of September 9, he circled the field about once a minute for nearly an hour. Later in the day, he flew for just over an hour and then invited Lieutenant Frank Lahm to climb on for a ride. They were aloft for six minutes, twenty-four seconds. Each flight set a new world endurance record. Orville kept flying and breaking his own records as he circled the field, made figure eights and climbed to altitudes estimated at three hundred feet.

Then came tragedy. Orville's plane crashed on September 17, killing passenger Lieutenant Thomas Selfridge, a twenty-six-year-old West Point graduate from San Francisco. Orville was diagnosed with a fractured left leg and four broken ribs, but X-rays years later would reveal he had also fractured his hip bone and dislocated it. The injuries would cause him pain for the rest of his life. The airplane was a loss, and the army suspended the flight trials.

Wilbur learned of the crash the next day. He was an ocean away, but he still felt guilty somehow for not protecting his younger brother. "I cannot help thinking over and over again 'If I had been there, it would not have

happened,'" he wrote to Katharine on September 20. "It was not right to leave Orville to undertake such a task alone…I do not mean that Orville was incompetent…[but a] man cannot take sufficient care when he is subject to continual interruptions and his time is consumed in talking to visitors…If I had been there I could have held off the visitors while he worked or let him hold them off while I worked."

Of course, Wilbur was in exactly the same situation. He was getting ready for a qualification flight when he learned of the accident. It was a perfect day for flying, but "I did not feel that it would be decent to proceed" in view of Selfridge's death, Wilbur wrote to Katharine. He postponed his flights for a week.

Orville conducted a crash investigation from his hospital bed. Taylor and Furnas brought him a broken propeller and some other parts. One blade of the right propeller had cracked. Orville made a preliminary finding that the crack had allowed the blade to flatten and lose thrust, causing severe vibration until the propeller came loose and struck a stay wire in the tail; the tail then flopped on its side, putting the plane into a steep dive to the ground.

Katharine immediately took a leave of absence from Dayton's Steele High School and rushed to Fort Myer. She stayed by Orville's side for more than six weeks until the hospital dismissed him. She returned home with him on November 1. Orville recovered slowly. The army doctors had treated his fractured leg with traction; the family doctor put it in a cast. The wrecked flyer was shipped back to the bicycle shop. Twice over the next two weeks, Taylor pushed Orville in a wheelchair up Williams and across West Third to the bicycle shop, where he went over the wreckage.

Wilbur continued to make flights in France, extending them to more than an hour and often taking passengers. On October 7, he took Berg's wife, Edith, who became the first American woman to fly in an airplane. He set numerous records and won cash prizes offered by French aero clubs. As the flying season waned in December, Wilbur moved his operations to Pau, a picturesque resort town in southern France.

Orville and Katharine joined Wilbur in Paris on January 12, 1909, and followed him to Pau, where he slept in his hangar while they stayed in a hotel. Katharine took her first airplane flight there. They stayed in Europe until May 5. During that time, the Wright brothers entered a contract with the Short Brothers of England to build six Wright airplanes; Short paid the brothers £1,000 for each airplane. Wilbur completed his work in France and signed a contract for demonstration flights in Germany. He also trained two Italian pilots at Centocelle Field near Rome.

Katharine and Orville Wright stand with a cabin boy on a German ocean liner bound for Europe in 1909. *Courtesy of Special Collections and Archives, Wright State University.*

Before leaving Europe, the Wrights returned to Le Mans to receive a fabulous bronze sculpture from the Aero Club of the Sarthe and to London for banquets and medals from the British aviation societies. The accolades continued in New York with a luncheon by the Aero Club of America.

By this time, the Wright brothers had become Dayton's first superstars. The city greeted their return on May 13 with a massive welcome home celebration. Ten thousand Daytonians massed at Union Station to greet the train. A special carriage drawn by four white horses carried them to their modest home at 7 Hawthorn, leading a procession of nineteen carriages. A mass of people followed while others lined the route. The whole procession had the air of a circus parade coming to town. They found their home and most of the houses on the street bedecked with flags and Japanese lanterns. At Fourth and Hawthorn, lanterns had been arranged to spell "Welcome."

Crowds packed the sidewalks and neighboring yards. As the carriage turned onto their street from Fifth, a band on a platform set up in front of their house struck up the tune "Home Sweet Home." Neighbors and distant relatives made speeches.[8]

Civic leaders were planning an even bigger celebration for the next month. In a June 6 letter to Chanute, Wilbur called it an "excuse for an elaborate carnival and advertisement of the city under the guise of being an honor to us." The hoopla was just an annoying distraction to the brothers. They needed to nail down the cause of the Fort Myer accident quickly because they were building a new airplane to complete the trials.

Wilbur and Orville cloistered themselves in their bicycle shop and in a shed behind Lorin's house to examine the crash evidence. They concluded that Orville's preliminary finding at the hospital was correct. Seeking to understand what had caused the propeller blade to crack, they discovered a flaw in their propeller testing that had masked the blade's weakness. They made new propellers that were stronger and braced the axle supports so that a similar propeller failure wouldn't allow a blade to contact the tail wires. "I am glad it was no carelessness of Orville that brought about the catastrophe," Wilbur wrote to Chanute on June 6.[9]

In late May, Wilbur and Orville traveled to the Packard Automobile Company plant in Detroit to meet with the brothers Russell A. and Frederick M. Alger. The wealthy Packard stockholders were interested in forming a company to produce Wright airplanes. The meeting would bear fruit later.

The Wright brothers traveled to Washington, D.C., in mid-June to endure a day of accolades and to receive the Aero Club of America medal from President Taft in a White House ceremony. Katharine accompanied them. They returned to Dayton for an even gaudier demonstration of hometown pride and municipal self-promotion.

Civic leaders had spent months organizing the massive festival. They had commandeered the National Cash Register Co.'s Welfare Hall, a huge employees' dining room, where a small army of craftsmen built props under the direction of noted Philadelphia designer Henry Kablerske. They constructed the elements of a lavish "Court of Honor," an array of Roman-style columns that would line three blocks of Main Street between Third Street and the Soldier's Monument at Monument Avenue, bracketed at each end by triumphal arches.[10]

The meticulously planned festivities started at 9:00 a.m. on June 17 with bells tolling, cannons booming and factory whistles shrieking. Separate carriages conveyed Wilbur and Orville to Van Cleve Park on Monument

A postcard shows a view of a parade honoring the Wright brothers in Dayton's Welcome Home celebration. *Author's collection.*

between Main and Jefferson, where a band concert led up to opening ceremonies and hours of presentations and speechifying. The Dayton Fire Department paraded its apparatus in the afternoon. On and on went the events. They wrapped up twelve hours later with a fireworks display along the Miami River. In between, Wilbur and Orville tried to get some work done in their shop, covering the windows with canvas to shield them from a crowd gathered outside.[11]

The celebration resumed the next day at the Montgomery County Fairgrounds, where 2,500 schoolchildren dressed in red, white and blue assembled in the pattern of an American flag. Wilbur and Orville received a pile of medals, including the Congressional Medal presented by General James Allen, Signal Corps chief. More events followed, including another parade, and the second day closed with an illuminated parade of automobiles.[12]

Wilbur and Orville left for Fort Myer the next day to complete the demonstration flights. Milton and Reuchlin joined them to watch preliminary flights. Katharine went in time for the official trial flight. The previous day, Orville had demonstrated a passenger flight with Lieutenant Frank Lahm; for the final flight, he stayed aloft for more than an hour and averaged 42.583 miles per hour, beating the contract's requirements. President Taft, his cabinet, other top government officials

Wilbur starts his flight from Governors Island. He lashed a canoe under the flyer in case he had to ditch in the water. *George Grantham Bain Collection, Prints and Photographs Division, Library of Congress.*

and a crowd of some ten thousand people witnessed the flight. Taft personally congratulated Orville after he landed. On August 2, Allen approved the purchase of the Wright airplane.

Orville and Katharine returned to Dayton on July 31, but on August 8 they were off again—to Berlin this time, where Orville was to make demonstration flights to complete the negotiations for the sale of Wright patents to a German syndicate that had been formed in May.

Wilbur capped the Wright brothers' 1909 public flights with the most spectacular feat yet. Between September 25 and October 4, Wilbur participated in the Hudson Fulton Celebration in New York. The event combined the tricentennial celebration of Henry Hudson's discovery of the Hudson River and a postponed centennial celebration of Robert Fulton's first use of steam power to navigate the river. Crowds estimated at one million people watched Wilbur make several flights, including one that circled the Statue of Liberty. His most epic flight was a twenty-one-mile loop from Governors Island up the Hudson River past Grant's Tomb and back. Because he would be flying over water, Wilbur fitted the airplane with a makeshift pontoon: a red canoe with a canvas cover.[13]

THE FLIGHT FACTORY

The two modest brick buildings that face Abbey Avenue between West Third Street and U.S. 35 in West Dayton are easy to miss; they're almost indistinguishable in a long row of attached buildings that includes three similar structures. For decades, massive manufacturing buildings surrounded them, hiding the smaller buildings from public view. These buildings were the Wright Company's airplane factory, later to become the birthplace of General Motors' Inland Division. Inland's epic success as a global auto parts supplier overshadowed the buildings' history as the birthplace of America's aviation industry. But just inside the entrance to Building 1, an intriguing mural covers the wall. Now faded, it shows Wilbur circling the Statue of Liberty in his canoe-laden flyer. The existence of these buildings owes much to Wilbur's exhibition flights at the Hudson Fulton celebration.

Wilbur was still in New York when a young man named Clinton R. Peterkin approached him. Peterkin was just twenty-four, but he had some powerful connections. He had worked as an office boy at J.P. Morgan & Company in New York, but health problems had forced him to go west. Now he was back, and he was looking for opportunities to broker business deals. He tracked down Wilbur at the Park Avenue Hotel and offered to use his connections to help the Wright brothers find investors to form a company. Wilbur told him the brothers wanted to talk only to "men of consequence," Kelly wrote in *The Wright Brothers*.

Peterkin met with Morgan, the legendary Wall Street banker, who agreed to buy stock on behalf of himself and his friend, Judge Elbert H. Gary, head

The original two Wright Company factory buildings (left foreground) and adjoining later buildings as they looked in early 2014. *Courtesy of the National Aviation Heritage Area.*

of U.S. Steel. Other top moneymen quickly joined in, including DeLancey Nicoll (a prominent financial lawyer), Cornelius Vanderbilt, August Belmont, Andrew Freedman and others. The Wright brothers also invited Robert J. Collier, publisher of *Collier's Weekly*, and the Alger brothers of Detroit. Despite their great wealth and power, the other investors feared Morgan and Gary would dominate the board of directors. They asked them to bow out, and the two men complied. The remaining group incorporated the Wright Company in New York on November 22, 1909. The stock issue raised $1 million. In exchange for the rights to their U.S. patent, Wilbur and Orville received $100,000 in cash, 40 percent of the stock and a 10 percent royalty on every airplane sold. The company also agreed to bear the expense of patent enforcement. It opened a corporate office at 527 Fifth Avenue. Wilbur became president, and Orville and Freedman became vice-presidents.

The Wright brothers never aspired to join the ranks of New York business tycoons. Writing to Chanute on December 6, Wilbur said, "The general supervision of the business will be in our hands though a general manager will be secured to directly have charge. We will devote most of our time to experimental work."

But their formation of a million-dollar company with some of the most powerful businessmen in America sent a shudder through the Dayton press.

Where would these East Coast capitalists locate the manufacturing plant? Would the Wright brothers, now rich and famous industrialists, abandon their hometown for big-city life? "Practically every city in the country will be after the airship factory," the *Dayton Herald* fretted in a page one story on November 23, 1909. "Dayton must act promptly to get it," it warned. "The location of their plant in Dayton would be the crowning feature of the Gem City."

It was a legitimate concern, but the editors needn't have worried. The Wright family was rooted in Dayton, and Wilbur and Orville wouldn't have dreamed of abandoning their father, Katharine and Lorin. "We propose to have the first and largest airship factory in the country—to have it here at home," Orville said in the *New York Times* on November 25 after signing the incorporation documents.

The Wright brothers began the hunt for a factory site, but they didn't want to wait to start production. They converted their bicycle shop into the Wright Company's engine plant and put it under Taylor's direction. They rented space for building airplanes from the Speedwell Motor Car Company. Speedwell had a big new factory less than two miles south, at

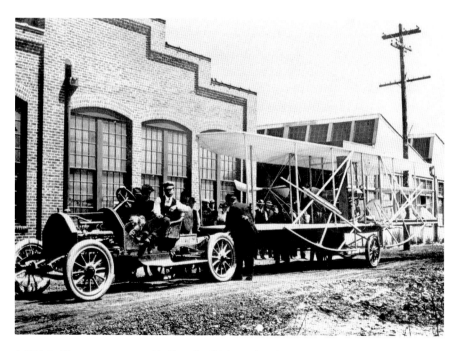

A Wright Flyer on a cart outside Speedwell Motor Car Company factory. *Courtesy of Special Collections and Archives, Wright State University.*

1420 Wisconsin Boulevard in the Edgemont District. The six-acre complex had space the automaker didn't immediately need, so Speedwell leased it to the Wright Company from January through September.[1]

In these facilities, America's first aerospace workforce began to take shape. Building an airplane requires an array of skills and a desire for precision workmanship. And no doubt the tireless Wright brothers expected their employees to harbor a strong work ethic. "'The great difficulty at present,'" an April 1910 *New York Times* story quoted Wilbur as saying, "'is to get the right kind of hands in our factory. We have got to teach each man his particular duty, and that takes a whole lot of time.'"[2]

The rented space at Speedwell gave the Wright Company the capacity to produce two airplanes a month. Its first product was the Model B. Wilbur and Orville gave its rollout the kind of fanfare you would expect from them: none. They loaded it onto a horse-drawn hay wagon, its front and rear sections stuffed between the wings, and hauled it out to Huffman Prairie. Transporting flyers out to Simms Station on wagons was a ponderous business, so workers typically moved them at night to avoid daytime traffic.

EVOLUTION OF THE B

Oddly, the Wright Company never produced a Model A. Historians presume that's how the Wright brothers thought of their 1907 flyer, the model they flew through 1909 and sold to the army. The company's first product was the Model B, introduced at the beginning of the 1910 flying season. The B was the first U.S. airplane manufactured in substantial numbers, and it became the company's workhorse.

Model Bs were used to train Wright Company pilots and many of America's pioneer aviators. Wright exhibition pilots mainly flew Model B planes. When the Wright Company transferred operations from Speedwell to its own plant, the Model B became the first airplane produced in a factory built for aircraft production. A Model B piloted by Phil O. Parmelee made the first commercial cargo flight on November 7, 1910, carrying two bolts of silk from Huffman Prairie to Columbus for the Morehouse-Martens Company. The first Wright floatplanes were Model Bs. Massachusetts yacht designer W. Starling Burgess also produced Model Bs in Marblehead under license as the Burgess Model F, also known as the Burgess-Wright.

An original, modified Wright B Flyer in the National Museum of the U.S. Air Force. Note the ailerons visible on the bottom wing. *Author's photo.*

The first Wright Model B didn't exactly roll out of the factory—it still sat on runners. The model evolved gradually from the 1907 design with a front-mounted elevator. The Wright brothers lengthened the tail and added a fixed horizontal stabilizer, then made it moveable in coordination with the front elevator. Next, they removed the front rudder. The Wright brothers "made some experiments with wheels" at Simms Station on July 21, according to Milton Wright's diary. A Model B with wheels under its runners first appeared in public on August 10 at an air meet in Asbury Park, New Jersey. The Wrights continued to make other small changes. Even in 1911, Wilbur added dihedral to the wings, and Orville added small, square vanes under the top wing in separate efforts to improve stability.

A century after Parmelee's cargo flight, the nonprofit heritage organization Wright "B" Flyer, Inc. reenacted the flight with a modern lookalike of a Model B. Instead of silk, the airplane carried samples of advanced materials and a micro air vehicle from the Air Force Research Laboratory at Wright-Patterson Air Force Base.

The only authentic Model B from the Wright Company factory that still exists is on display in the Franklin Institute in Philadelphia. A highly modified Model B with ailerons is on display in the National Museum of the U.S. Air Force.[3]

The Wright Company factory in 1911. *Papers of Wilbur and Orville Wright, Prints and Photographs Division, Library of Congress.*

Despite their stated desire to remain in Dayton, the Wright brothers' use of a rented factory must have made some wonder about their true intentions. Their decision to buy a big lot for a new home at Salem and Harvard, north of downtown, made front-page news. "When the Wright brothers became the heroes of the aviation world, Dayton's ability to hold them was at once questioned," the *Dayton Daily News* noted on January 10, 1910. It said their purchase of a residential lot "clearly indicates that they have no thought of making any other city their permanent home. It is also accepted as a strong indication that the factory will be permanently located in this city." As it happened, the Wright family gave up the lot for a site in suburban Oakwood. But the initial purchase made it clear they weren't leaving the area.

Civic leaders faced the happy prospect of a whole new industry for Dayton. The chamber of commerce made plans to include a special "Aviation Day" in a six-day fall festival and industry expo planned for September. The event would take over the central business district and involve the erection of a massive expo hall, longer than a football field, on public land between Second and Third Streets. "Aviation Day" was to include, of course, flying exhibitions. The "City of a Thousand Factories" would welcome its 1,001[st] in grand style.[4]

Wilbur and Orville had no desire to run a factory. For that job Russell Alger suggested his cousin, Frank Russell. "He has had a great deal of factory experience under very adverse conditions, and he is fully qualified in that direction. He has had also a good deal of business experience. He is

a natural mechanic," Alger wrote on November 29. Wilbur met with Frank Russell in December and agreed to hire him. He moved his family to Dayton in January 1910 and reported to the Wrights in their office over the old bicycle shop. With no more space available there, the Wright brothers found him a room in the rear of a plumbing shop down the street.

Renting space from Speedwell gave Wilbur and Orville time to find a permanent location. They didn't have to look far. Straight out West Third, just a mile and a half from the bicycle shop and their home, a cornfield was ripe for development. It lay along Coleman Avenue between West Third and a line of the Cincinnati, Hamilton and Dayton Railway. Dayton was growing toward it from the east, closing the gap between the center city and the National Soldiers Home (now the Dayton VA Medical Center) less than a mile farther west.

The Wright brothers ordered construction of a 230- by 60- foot brick structure with a steel frame roof. The new building would give them half again more space than their Speedwell location and would meet their needs "until the business develops further," Wilbur wrote in an August 29 letter to Russell Alger. Designed by Dayton architect William Earl Russ, the factory was a long, single-story brick building with arched parapets. Each side had a row of large windows, and skylights ran most of the length of the roof. The company had its first building up by November 1910. The company added a second, smaller building of matching style in 1911. Together, the two buildings enclosed 20,000 square feet with the capacity to produce four airplanes per month, or about one a week.[5]

Inside, the factory was "as businesslike and commonplace as a shoe factory," Erwin Ellis wrote in the September 20, 1911 issue of the *Chicago Daily Tribune*. But the Wright Company factory had one thing you would never find in a shoe factory: a flight simulator. Its users included some of America's most legendary aviation pioneers. Among them was Henry H. "Hap" Arnold, who would become the first U.S. Air Force chief of staff and the only air force general to wear five stars.

Arnold described the Wright Company's primitive simulator in his autobiography *Global Mission*. Almost as soon as he arrived as a young army lieutenant in May 1911, his instructor took him to "a back room of the shop where an old plane was balanced on sawhorse supports so that the wingtips could move up and down."

Taking the pilot's position on the wing, students would practice working the controls. "No two types of controls were the same in those days," Arnold wrote. He considered the Wright controls the most difficult of all. It used

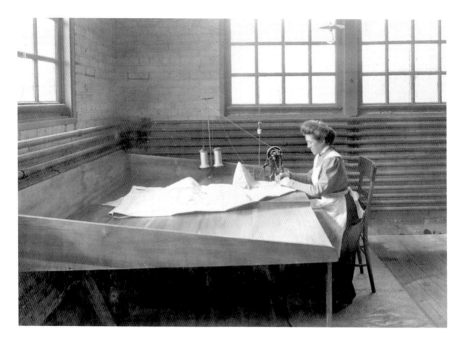

Wright Company employee Ida Holgrave in the sewing department, 1911. She was one of America's first female aerospace workers. *Courtesy of Special Collections and Archives, Wright State University.*

two levers, one on each side of the pilot. One moved fore and aft to move the elevator, which controlled pitch. The other also moved fore and aft, but it warped the wings for roll control. Attached to it was a handgrip to control the rudder.

"This scarcely instinctive procedure had to be mastered before one could go into the air to be a Wright pilot," Arnold wrote. He continued,

> *The old plane mounted on a sawhorse was how you began. The lateral controls were connected with small clutches at the wingtips, and grabbed a moving belt running over a pulley. A forward motion, and the clutch would snatch the belt, and down would go the left wing. A backward pull, and the reverse would happen. The jolts and teetering were so violent that the student was kept busy just moving the lever back and forth to keep on an even keel. That was primary training, and it lasted for days.*[6]

The factory was also where students learned how to maintain and repair their machines. As Arnold noted, "there were no crew chiefs nor aircraft mechanics in the Army in those days."

Airplane production began during a boom time for Dayton. In 1910, the city was the forty-third largest in the United States by population and the fourth largest in Ohio. Its population of 116,577 people had swelled by 31,000 in a decade. In both size and economic impact, the Wright Company factory was small potatoes. But the nature of its business made it special. The chamber of commerce's massive Dayton Industrial Exposition and Fall Festival in September was focused on the surging automobile industry, but it used aviation as a marketing tool. Advertisements placed in 150 newspapers across Ohio and Indiana featured a Wright Flyer and promised aerial activities under the direction of the Wright brothers.[7]

Thursday, September 22, was the expo's "Aviation Day," featuring a flight by Orville across the city from Huffman Prairie. As Milton described it in his diary, the flyer appeared in the sky about 5:00 p.m., some two thousand feet up. Factory whistles screamed to signal its approach, the *Dayton Daily News* reported. As the flyer passed overhead, "the faint crackling staccato of its unmuffled motor" reached the crowd below. Orville flew over his home, then along West Third to the city limits, apparently passing over the bicycle shop where they had invented the airplane and the site for their new factory. Climbing to four thousand feet, he turned east and followed the Mad River back to Huffman Prairie. "Many thousands saw him," Milton wrote.[8]

Despite the factory's ample capacity, production lagged. Instead of building an airplane a week, the factory completed and delivered only four airplanes to outside customers in the first half of 1911. It delivered two more to its own exhibition department in that period. Orders for six more were

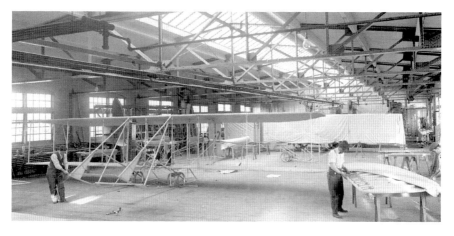

A view of the general assembly department in the Wright Company factory, 1911. *Courtesy of Special Collections and Archives, Wright State University.*

due in July, but only two airplanes were near to completion. "Work in the factory does not seem to move very fast," Orville observed in a July 5 letter to Freedman.

The Wright brothers laid much of the blame on Frank Russell. Orville considered him lazy and vented about him in letters to his brother while Wilbur was in Europe to check on their foreign interests. "I can not see that Russell is showing any more initiative than he did last year. His 'organization' enables him to spend nearly all his time talking or visiting the field," he complained in a May 23, 1911 letter to Wilbur. He continued the rant in a June 4 letter. Referring to the companies of rival Glenn Curtiss and Wright licensee W. Starling Burgess, he wrote, "Sales of machines have not been numerous lately. The Curtiss [and] Burgess people seem to be selling more than we are…I can't see that Russell has done anything to push this end of the business." Wilbur complained to Russell Alger in a September 29 letter that his cousin was "disturbing the general organization" of the company, as Alger acknowledged in an October reply.

There was little love lost between the Wright brothers and Frank Russell. Correspondence between the Wrights and Russell Alger hinted at friction in the first year. Russell Alger conceded his cousin wasn't perfect, but he suggested the Wright brothers shared some of the blame. The brothers were "somewhat inclined to your own ideas," he wrote to Wilbur in a November 17, 1910 letter, adding that suggestions for "in any way changing small engineering details would not be received with any too much enthusiasm by you and your brother."

Frank Russell wanted to make a slew of changes, and not simply in small details. He wanted to increase production capacity, make the exhibition business more competitive, step up prosecution of the patent suits, expand the product line and promote the company, according to a letter he wrote to Freedman in July 1911. Russell blamed the slack delivery rate on a bottleneck in engine production and urged the addition of more manufacturing equipment. He also urged the company to hire a salesman to take over sales and publicity under Russell's direction. "Up to this time there has been no systematic publication of news items either in trade papers or general publications. Our plant is the only complete aeroplane factory in America, yet the public knows little or nothing of our progress," he complained in a July 28, 1911 letter to Freedman.

Russell also wanted the company to add floatplanes to its product line. "Sportsmen as well as the Government are insistent on our installing pontoons…The Curtis [sic] Company covers this field alone," he wrote in

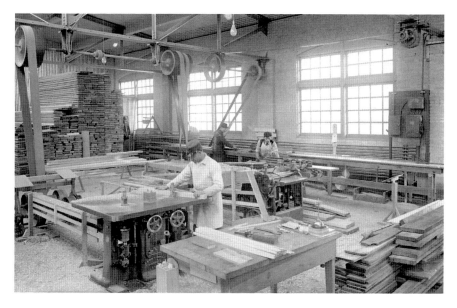

Wright Company employees Dan Farrell, Frank M. Quinn and Bill Conover in the woodworking department. *Courtesy of Special Collections and Archives, Wright State University.*

the July 28 letter, and he added, "I think an aeroplane should be installed at some suitable locality and experimental work immediately commenced."

Russell didn't stick around long. The brothers notified Andrew Freedman in an October 4, 1911 letter that they were accepting his resignation effective January 1, 1912.

But the Wright brothers eventually did much of what Russell had suggested, including getting into the floatplane business. While some Wright history buffs believe the Wright Company's first floatplane was the 1913 Model C-H, records show the company was developing a floatplane version of a Model B as early as 1911. Russell Alger also experimented with floats on his own Model B. A yachtsman, he had just built a country villa on the shore of Lake St. Clair at Grosse Point, east of Detroit. When Frank Russell left the Wright Company, he went to Michigan to help his cousin with his floatplane work before joining Burgess in Massachusetts, who was building Wright airplanes under license in his Marblehead plant.

Besides experimenting with different float designs, the Packard vice-president experimented with a crank starter to allow a pilot to start the plane's engine while standing on one of its floats; starting it the usual way, by flipping the Model B's rear-mounted propellers, wasn't practical in the middle of a lake. Alger also experimented with a way to raise and lower the

floats so the airplane could land on the ground with its runners if desired, as well as a way to raise and lower wheels. Either modification would have resulted in an amphibious Model B. Frank Coffyn, one of the Wright Company's original exhibition team members, served as Alger's test pilot. In an October 25 letter, he told Orville that Coffyn had carried Alger and Frank Russell together on a five-minute flight off the water.

Orville and Alger corresponded about their floatplane work. By the end of 1911, the Wright factory had several projects underway, all with a Model B floatplane in mind. One was a more powerful, six-cylinder engine that would use either a hand crank or a gasoline-powered auxiliary starter. Another was a plan for retractable wheels. Most striking was an advanced, multistep float intended to reduce drag for more efficient takeoffs. Archived photos show a Wright Model B in the factory mounted on twin floats with distinctive, sawtooth-like bottoms. Orville noted the wooden floats were heavier than he had hoped, mainly because of the white lead paint used to seal them.

Orville told Alger in a December 28 letter that the Wright Company hadn't tested a plane on floats because "our river here is rather small for any very extensive experiments along this line"—a reference to the narrow, tree-lined Great Miami River. The lack of easy access to large bodies of water is likely why Frank Russell had suggested testing floatplanes "at some suitable locality." But at the end of August 1912, Orville told Alger he had begun "a little experimenting" on the Great Miami south of Dayton.

Alger hoped their floatplanes would appeal to wealthy yachtsmen on the East Coast who were beginning to see floatplanes as the latest sport. So did Alpheus Barnes, the company's treasurer in New York, who was close to the yachting scene on Long Island. Coffyn, son of a New York banker himself, took Alger's Model B floatplane to New York in the winter of 1912. Undeterred by the weather, Coffyn made headlines through February with daring flights off the icy, choppy Hudson River at Brooklyn. He managed to fly through the winter without a serious mishap, but he was seriously injured in a car accident in March. Alger sold his Model B to Coffyn out of sympathy, hoping it would help him get back on his feet by winning some prizes in an upcoming floatplane race in New York.

The Wright Company received orders with cash deposits for floatplanes as early as January 1912. Barnes relayed the names of several East Coast men who wanted one. The Glenwood Country Club at Glen Head, Long Island, formed an aviation committee that envisioned a row of hangars along the water for its members' floatplanes, according to an article in the September 1912 issue of *Aeronautics*. It built a hangar and launching ramp

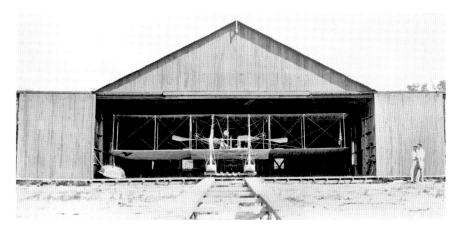

A Wright Model B Flyer on twin pontoons in its hangar at Glen Head, New York. *Courtesy of Special Collections and Archives, Wright State University.*

for a Wright Company plane. Charles Wald, a New York resident who had taken some flying lessons at Huffman Prairie, returned to Dayton in June to complete his training and then went back to Glen Head to demonstrate the floatplane—an old Model B on the company's new floats. Wald also was to operate a Wright flying school at Hempstead Plains, a natural prairie on Long Island that had become a hotbed of flying. The army also took an interest in floatplanes for coastal defense; it ordered one floatplane each from the Wright, Burgess and Curtiss companies.

Wald made several flights with the floatplane and carried a few passengers in September and October. He had his best and worst day on October 10. At 4:00 p.m., he flew to the rescue of Walter Strobach, an inexperienced swimmer from Flatbush who had capsized his rowboat in Hempstead Harbor. Wald pulled him from the water and flew him back to shore. The aerial rescue merited a brief story in the *New York Times*. But that evening, a flight with a newspaper correspondent ended badly when the plane flipped over on touchdown. Wald and the reporter apparently were uninjured, but that ended the Wright Company's floatplane flying at Glen Head.[9]

One reason for lackluster sales was that competition was already in place by the time the Wright brothers had formed their company. The competitor was someone they had met a few years earlier: Glenn Curtiss.

Born on May 21, 1878, in Hammondsport, New York, Curtiss was eleven years younger than Wilbur and seven years younger than Orville, but he shared their fascination with mechanical devices, bicycles and speed. He opened a bicycle shop in 1900 and soon began designing and building

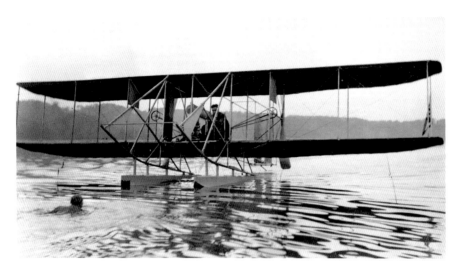

Charles Wald reenacts a water rescue with a Wright Model B floatplane at Glen Head, New York. *Courtesy of Special Collections and Archives, Wright State University.*

motorized bikes. While the Wright brothers were inventing the airplane, Curtiss was winning races and setting speed records on his motorcycles. His light but powerful motorcycle engines drew the interest of commercial balloonist Thomas Scott Baldwin, who bought one for his dirigible, the *California Arrow*. Suddenly Curtiss was in the aviation business, making engines for Baldwin and other lighter-than-air pilots.[10]

Curtiss had written to the Wright brothers in May 1906 about his lightweight engines. Already making their own, the brothers weren't interested. The brothers finally met their future rival in September 1906 when they went to see Baldwin and his famous airship at the Montgomery County Fairgrounds. Baldwin had summoned Curtiss there to work on the engine. The brothers invited Baldwin and Curtiss to visit their bicycle shop, where Curtiss is said to have peppered them with questions. Years later, Baldwin said the Wrights gave Curtiss access to their data and freely answered his questions. Curtiss put his new knowledge to quick use. Just over a week later, he sent the brothers a letter in which he described how he had modified the propeller blades on Baldwin's dirigible to improve their performance.[11]

More alarming was the *June Bug*, the biplane that Curtiss built and flew on July 4, 1908, to win the *Scientific American* trophy for the first one-kilometer public flight in America. Instead of warping wings, the *June Bug* had hinged control surfaces on the wingtips called ailerons. The Wright brothers still

considered it an infringement, as Orville warned him in a letter on July 20. Undeterred, Curtiss joined with Augustus Herring to form the Herring-Curtiss Company in February 1909. They produced the *Golden Flier*, a biplane with the ailerons mounted between the wings. Curtiss sold it on June 26 to the Aeronautic Society of New York. It was the first commercial sale of an airplane in the United States; Wilbur and Orville had yet to form their own company.

Curtiss was already showing his quickness and drive. He had made the first public flight in America, formed the first production company and made the first commercial airplane sale. Of course, he had the benefit of the Wright brothers' research and no great secrets of his own to make him cautious. But Grover Cleveland Loening, who would work under Orville and later get to know Curtiss, saw them as two very different types: "Curtiss was a promoter with vision; Wright was an engineer and a scientist," he wrote in his book *Takeoff into Greatness: How American Aviation Grew So Big, So Fast*.

In August, Wilbur sued the Herring-Curtiss Company and Curtiss for infringement, and he sued the Aeronautic Society of New York to prevent it from flying the Curtiss machine. It was the beginning of a contentious period of lawsuits and legal maneuvering that became known as the patent wars. The Wright brothers also sued two prominent aviators for flying unlicensed foreign airplanes they had brought into the country, and they sued exhibitors who allowed unlicensed fliers to compete without paying the Wright Company a fee. They were high-profile cases that would split public opinion over whether the Wright brothers were simply protecting their rights or trying to monopolize the aviation industry. Many would blame Wilbur and Orville for retarding aeronautical advancement in the United States—a strange accusation considering the Wright Company steadily lost ground to Curtiss and others.

The most important case was the Wright brothers' suit against Herring-Curtiss and Glenn Curtiss. When he filed the lawsuit, Wilbur also asked for a preliminary injunction to prevent Curtiss from using the technology in their patent until the case was decided. It was a complex case and likely to take months or years to adjudicate; without an injunction, Curtiss would be free to compete just as the airplane market was emerging. On January 3, 1910, Judge John R. Hazel in the U.S. Circuit Court in Buffalo granted the injunction. In *The Bishop's Boys*, Crouch wrote it was uncommon to grant an injunction in such thorny cases, but Hazel found the evidence already at hand was compelling.

The directors of Herring-Curtiss folded the company, but Glenn Curtiss formed a new one and pressed on, appealing the injunction. On June 14,

the Circuit Court of Appeals reversed Hazel's decision and dismissed the injunction. Curtiss was free to continue making and selling airplanes; convinced he would eventually prevail, he did just that.

Wilbur directed the Wright Company's legal battle, beginning a struggle that would consume the rest of his days. He couldn't have dreamed he had less than two years to live.

7

STORMING THE SKY

Try to imagine the thrill, back in 1910, of flying on an early Wright B Flyer.

Perched on the front edge of the lower wing, you have an unobstructed view of the world. There's no enclosing fuselage or windshield to block the rush of air that begins as soon as you start your takeoff run. The roar of wind in your ears quickly displaces the thrum of the big propellers behind you. As you lift off, you can look down between your knees and watch the earth fall away.

Well, you don't have to imagine it. Wright "B" Flyer, Inc., a nonprofit based out of Dayton-Wright Brothers Airport south of the city, flies a one-of-a-kind, modern lookalike of a Model B. An Honorary Aviator membership includes a free orientation hop down the airport's five-thousand-foot runway. Designed and built by volunteers in the 1970s and early '80s, their Wright B Flyer is patterned after a highly modified Model B that's on display in the National Museum of the U.S. Air Force. Some of the major changes from the stock Wright Company airplane included ailerons and a steering wheel.

Research for this book included a flight on the "B" over the suburbs and farmland south of the airport. The view was spectacular, with nothing more than the flyer's runners and one's own feet blocking the view. Tom Walters, the volunteer pilot, said his body often feels subtle shifts in wind direction and even temperature as he flies.

It's hard to imagine what the experience must have been like for a passenger or student pilot at the dawn of aviation. What was there to compare with it?

Here's how the world looks from Wright "B" Flyer, Inc.'s lookalike airplane—no fuselage, no windshield. *Author's photo.*

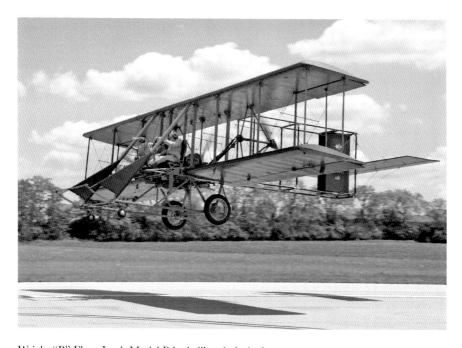

Wright "B" Flyer, Inc.'s Model B lookalike. *Author's photo.*

From the ground, Amos Root likened a Wright flyer to a "locomotive, with wings." Sitting on the wing, cruising through the sky with the world sliding by a thousand feet below, it must have seemed like a magic carpet ride.

By 1909, the age of the magic carpet was at hand. Experimenters were going into business. Brave young men—and a few brave women—were about to begin storming the sky.

The Wright brothers knew they would need to promote their airplane. They already faced competition from what they called "infringers"—Curtiss in the United States and others abroad. Their main marketing tool would be an exhibition team. Roy Knabenshue, a balloonist from Toledo, Ohio, had contacted them before their public demonstrations about buying airplanes for exhibitions, but at that time they weren't interested. Wilbur got back to Knabenshue in August 1909. They exchanged letters for months as Knabenshue sought to form his own team and buy Wright planes or even build his own and pay a royalty. He finally joined the company in March 1910 as head of its exhibition department. He took a downtown office at 40 South Main Street. As a secretary, he hired Mabel Beck, who in later years would become Orville's personal secretary and gatekeeper.

Huffman Prairie was too wet to use in early spring, and Ohio at that time of year isn't a great place to fly without an enclosed cockpit. Wilbur scouted the southern states for a place where they could set up a temporary flight-training center. In Montgomery, Alabama, the Commercial Club sensed an opportunity to promote the city. It gave Wilbur a tour of the area and showed him several large tracts of available land. The clincher was cotton grower Frank D. Kohn's offer—free use of a large, treeless field. Wilbur accepted, but on his way back to Dayton he stopped to check additional sites in Augusta, Georgia—another city that would play a part in the Wright Company's history.[1]

The Wright brothers sent Charles Taylor to Montgomery to set up the training camp. He arrived on March 19 with an airplane and spare parts. With him were the company's first two students, J.W. Davis of Colorado Springs and Daytonian Walter Brookins. Orville arrived on March 24 with another student, Spencer C. Crane, also of Dayton.

Brookins was well known to the Wrights. A former student of Katharine's Central High, "Brookie" had been hanging around their bicycle shop since age four, fascinated by the flying machines they were making. In Montgomery, he caught on so quickly that Orville left him behind to continue instructing the others when he returned to Dayton on May 7. Davis washed out but stayed on as a handyman. Crane failed to get his wings and left the program.

Orville Wright and students in Montgomery, Alabama. *From left*: Arthur L. Welsh, Spencer Crane, Orville Wright, Walter Brookins, James Davis and Archibald Hoxsey. *Courtesy of Special Collections and Archives, Wright State University.*

The Montgomery school closed in early May, but the site would continue to attract aviation activities; today, it's the location of Maxwell Air Force Base and the home of the U.S. Air Force's Air University.

Back in Dayton, Brookins completed training the core exhibition team under Orville's oversight. The team included Leonard Bonney of Wellington, Ohio; Coffyn; Howard Gill, an auto racer and balloonist from Baltimore; Arch Hoxsey, Pasadena auto racer and mechanic; Ralph Johnstone of Kansas City; Parmelee, of Matherton, Michigan; J. Clifford Turpin, the first Purdue University graduate to become a pilot, and A.L. "Al" Welsh of Washington, D.C. Orville treated them all like family: no drinking, no gambling and no flying on Sundays.[2]

Unlike the flimsy sheds of 1904 and '05, the Wright Company hangar on Huffman Prairie was a substantial barn-like structure with corner posts sunk into the ground and raised wooden floors. On the front wall, a pair of sliding doors hung from tracks that extended beyond the building on each side.[3]

Flying activities became a common sight on Huffman Prairie, and curious crowds began to line the road. The *Dayton Daily News* published directions to the field. In late May, with their first exhibition approaching, Orville flew frequently—often several times a day. Witnesses said it was never difficult to

pick him out. While the other pilots sported special suits, helmets, gauntlets and other aviator accessories, Orville always wore an ordinary business suit, sometimes with a pair of driving goggles and his cap turned backwards.[4]

The ancestor of Dayton air shows took place on Wednesday, May 25, when the Wright brothers held an exhibition for the Dayton Aero Club, one of two clubs local aviation enthusiasts had formed. It was a private event, but the press reported it ahead of time. A crowd reported to number between two thousand and three thousand lined the roadway, and food vendors plied them with ice cream and sandwiches. They saw history made: Wilbur and Orville, with Orville as pilot, made their only flight together. Orville also gave their eighty-two-year-old father his only flight, taking Milton aloft for just under seven minutes and reaching a modest altitude of 350 feet. Milton barely mentioned it in his diary entry for the day, but Kelly wrote that the bishop asked Orville to "Go higher, go higher."[5]

One reason Huffman Prairie was such a busy place in May 1910 is because the Wright Company's exhibition team was getting ready for its big debut. On June 13, the infield of the Indianapolis Motor Speedway became the scene of a national air meet. Both Wright brothers attended with their exhibition team and several Wright airplanes. June 17 was designated Wright Day, according to news reports. The International Aeroplane Club of Dayton chartered a special train for local citizens who wanted to show hometown support. The Wright team dominated the meet and set numerous records, in part because the meet drew few competitors. The injunction against infringing airplane makers was still in effect.[6]

Huffman Prairie wasn't just a hangout for the exhibition boys; it was the Wright Company's flight academy. A Wright School of Aviation pamphlet of 1912 promised aspiring students up to four hours of actual flying spread over one to two weeks, with each lesson typically including five to fifteen minutes in the air. The instructor always accompanied the student, "ever present and ready to resume control should the student make any serious mistake." Two to three hours aloft was usually enough for a student to become competent, and a student usually had his wings in a week to ten days. Tuition was $500 and payable on admission, but the pamphlet offered a sweetener: "the pupil is not held responsible for any breakage of the machine."

Classes included both civilian and military students. The graduates included many pioneer aviators who would become the architects of the air age. Among them were Hap Arnold; Marjorie Stinson and her brother, Stinson Aircraft Company founder Edward Stinson; and A. Ray Brown, a Royal Air Force pilot from Ontario who, in World War I, would be credited

Marjorie Stinson seated in a Wright Model B at Huffman Prairie. She enrolled in the Wright school at age eighteen. *Courtesy of Special Collections and Archives, Wright State University.*

by the RAF with shooting down Manfred von Richthofen—the infamous Red Baron.[7]

Arnold's first twenty lessons ranged from three to sixteen minutes as he learned to work the controls, land and taxi. Between May 3 and May 13, 1911, Arnold logged twenty-eight lessons with three hours and forty-eight minutes aloft, according to his book *Global Mission*. It was enough for Welsh to sign him off as an aviator.

For each precious minute in the air, students and instructors spent much more time on the ground, waiting for conditions suitably benign for their delicate machines and their fledgling skills. They occupied themselves by discussing and analyzing others' misfortunes, comparing the features of various flying machines and swapping tales. It was the beginning of the tradition still known as "hangar flying." Arnold thought the best times were when the Wright brothers themselves joined in—"quiet Orville in his derby and business suit, the even gentler Wilbur in plain cap—you never recognized them, but when they were in the air they could be spotted miles away," Arnold wrote.

Huffman Prairie wasn't the Wright Company's only training site. Besides the temporary school in Montgomery, in 1911 the company opened seasonal training camps on Long Island and in Augusta.

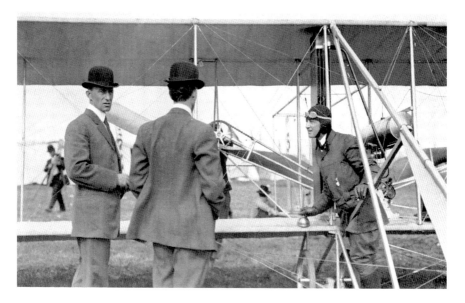

Wilbur (left) and Orville talk to Ralph Johnstone prior to a flight in a Wright airplane.
Courtesy of Special Collections and Archives, Wright State University.

In New York, the Aero Club of America had acquired a field on the Hempstead Plains, a huge expanse of flat, treeless prairie that made it a hotspot for New York flying activities. Wealthy East Coast men were lining up to order airplanes and learn to fly them for sport. The Wright school became one of several tenants on the Aero Club's field. The company sent Welsh there to supervise the assembly of two Wright airplanes for their owners and a third one for company use. *Town and Country* magazine covered Welsh's flights with high-society people, including friends of Robert Collier, a Wright Company director.[8]

The school was seasonal. Welsh closed it in November, never to return: other assignments kept him away the next spring, and in June 1912 he died in the crash of a Model C he was demonstrating for the army at College Park. Lieutenant Leighton W. Hazelhurst Jr., a West Point graduate and Signal Corps aviation cadet, died with him. It was one of several fatal crashes that would make the Model C infamous among early airmen. Charles Wald took over the Hempstead Plains school in addition to his floatplane flying at Glen Head, eight miles north. The Wright Company continued to operate a seasonal New York school through 1916.[9]

The company returned to Augusta in January 1911. It was one of the cities Wilbur had considered for the exhibition team's winter camp the

year before. Now it dispatched Frank Coffyn to open a school on Monte Sano Hill. The Augusta Chamber of Commerce had agreed to make one hundred acres available and put up a large hangar in return for $2,000 and weekly exhibition flights at the Augusta Fair Grounds. W. Starling Burgess was the first student. Today the site is home to Daniel Field, a general aviation airport the city established in 1924, according to a 2003 article in the *Augusta Chronicle*.[10]

After Orville sold his interests in the company in 1915, the new owners reorganized the flight training program into a subsidiary named Wright Flying Field, Inc., with operations in New York and Augusta. The school still used a Wright Model B for training, according to a 1916 advertising brochure. The brochure also pictured a Wright Model K floatplane. Howard Rinehart, who had become Orville's chief instructor on Huffman Prairie, closed that school in December 1915 while continuing the one in Augusta. Instruction alternated with the seasons between Augusta and New York.

The New York school amounted to a camp with airplanes. Ads for it portrayed flying as "the greatest sport of red-blooded, virile manhood"

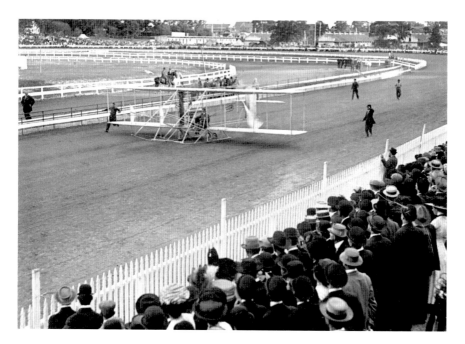

Archibald Hoxsey taking off in a Wright Model B Flyer from the racetrack at the Wisconsin State Fairgrounds in 1910. *Courtesy of Special Collections and Archives, Wright State University.*

and invited students to "live in the open—in the aviators' tent city." In contrast, ads for the Augusta school said it was located "at the well known winter resort."[11]

The Exhibition Department ostensibly existed to stimulate the market for Wright airplanes. But its biggest value to the Wright Company was the money it raked in from exhibition fees and prizes. Between June 1910 and September 1911, the company's pilots appeared at events and competitions across North America. They reaped a profit of $190,298.28 against total revenues of $272,863.16, according to *The Wright Company: From Invention to Industry*, by Edward J. Roach, National Park Service historian. Exhibition revenues in 1910 accounted for much of the company's $100,000 profit, allowing it to cover all the costs of its first factory building and still reward its investors with a year-end dividend. Wilbur and Orville split a $50,000 share of the 1910 profits.

One reason the exhibition business was so lucrative to the company is because the pilots didn't share in the winnings. Some pilots on the exhibition circuit—including some Wright school graduates, such as Cal Rodgers—entered contests on their own. If they won, they stood to win huge purses; but if they didn't, or if the contest went poorly and the organizers wouldn't pay, they lost their investment. Wright Company pilots wouldn't get rich, but at least they got paid. Brookins received twenty dollars a week as a retainer and fifty dollars per day for the days he flew.[12]

THE VIN FIZ

Exhibition flying boomed across America in 1910. In 1911 the Wright Company introduced the EX, an airplane made expressly for exhibition flying. With smaller wings and a bigger engine than the Model B, the single-seat Model EX was a swift little airplane, with a climb rate of up to six hundred feet per minute and a sixty-mile-per-hour top speed. The Wright Company didn't sell many, but an EX would become one of the most famous airplanes in aviation history.

Calbraith "Cal" Rodgers was a big, adventurous, cigar-chomping man. Born in Pittsburgh in 1879, he caught the flying bug while visiting his cousin John Rodgers in Dayton, where the navy had sent him to learn to fly. Cal Rodgers took lessons between June and August 1911, bought a Model B and immediately entered the

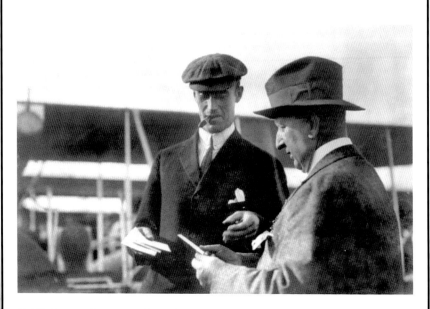

Cal Rodgers (left) in 1911. *George Grantham Bain Collection, Prints and Photographs Division, Library of Congress.*

Chicago International Aviation Meet, winning $11,285. His success encouraged him to go after a bigger prize: the $50,000 Hearst prize for the first transcontinental flight. He bought a Model EX and picked up a major sponsorship from the Armour Company, which covered Rodger's costs in return for having the name of its new grape soda—*Vin Fiz*—painted on the plane. Charles Taylor left the Wright Company to work as Rodgers's crew chief.

With Taylor following in a special train outfitted as a rolling repair shop, Rodgers took off from Sheepshead Bay, New York, on September 17, 1911. He arrived in Pasadena, California, on November 5. He had flown 4,321 miles at an average speed of 51 miles per hour. Crashes and repairs were frequent. Rodgers didn't come close to meeting the Hearst prize's thirty-day deadline, but he secured his place in aviation history. Just five months later, Rodgers was making a routine flight in his Model B along the shore at Long Beach when the airplane suddenly plunged into the surf. Rodgers died in the crash. Today, the reconstructed *Vin Fiz* hangs in the Smithsonian National Air and Space Museum.[13]

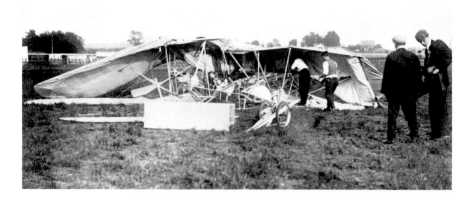

Ralph Johnstone's crash on October 10, 1910, at a meet in St. Louis was one of many mishaps by exhibition pilots—and not Johnstone's last. *Courtesy of Special Collections and Archives, Wright State University.*

The exhibitions didn't offer prizes for dangerous stunts, and the Wright brothers warned the company's pilots against trying to be daredevils. "I am very much in earnest when I say that I want no stunts and spectacular frills," Wilbur wrote in a September 19, 1910 letter to Hoxsey.

But the exhibition pilots were daring young men with competitive spirits, a taste for speed and a sense of immortality. Flying safe, predictable maneuvers might win a prize, but a spectacular stunt could bring a crowd to its feet and put the pilot in headlines all over the country. It was a recipe for disaster.

Johnstone was the first to die. At a Denver air meet on November 17, 1910, Johnstone was in a spiraling glide above Overland Park when his plane suddenly banked steeply and threw him from his seat. Johnstone hung onto the control levers, but the plane fell in a tight, spiraling dive to earth. Press reports said a wing collapsed, but Wilbur later speculated the wings were merely extremely warped from Johnstone's desperate hold on the levers. Spectators mobbed the crash scene and tore souvenirs from the airplane and Johnstone's body. He was the first American pilot to die in a plane crash.[14]

Hoxsey was next. Flying on the last day of the year at Dominguez Field, he had gone into the clouds for an altitude record. Watching for him to reappear, spectators saw him suddenly break out of the clouds in a descending spiral. His plane leveled off, causing everyone to think it was another stunt, but then its wings dipped, and it augured in just like Johnstone's.[15]

Wright exhibition pilots weren't the only ones dying in spectacular fashion. John B. Moisant fell out of his Blériot in New Orleans on the same

day Hoxsey crashed. Around the world, twenty-nine aviators died in 1910, many of them in front of crowds.[16]

The press gave the crashes lurid coverage. The *Rocky Mountain News* illustrated its November 18 story about Johnstone's death with a sketch of a skull-faced "angel of death" seated next to him on his plane. The front page of the November 19 *New York World* carried a C.R. McCauley cartoon titled "The Silent Spectator," which portrayed Death standing in an open grave, expectantly watching Johnstone fly over.

Profits from the exhibition department plummeted in 1911. More independent fliers were getting into the exhibition business, lured by big prizes and adventure. "I may say that Mr. Knabenshue has been very much discouraged with the work this year," Orville wrote to Freedman on July 5, 1911. He said foreign aviators and others were willing to fly for half what the Wright Company was charging, undercutting the company to the point that it couldn't profitably compete. Fewer exhibitions were available, and some that lost money tried to stiff their creditors.

Wilbur was ready to throw in the exhibition towel. In fact, by the middle of 1911, he was fed up with the whole business. He was traveling constantly and saw no end to the headaches of mismanaged foreign companies and the constant patent battles. "If I could get free from business with the money we already have in hand, I would rather do it than continue in business at a considerable profit," he wrote to Orville from Berlin on June 30. Only his sense of principle bound him. They had an obligation to their investors, and he couldn't abide the notion of allowing "a lot of scoundrels and thieves to steal" their patents.

"If it appears that the exhibition business is not really profitable my idea would be to get out of it as soon as possible," Wilbur wrote. "Only big profits and a quick release from worry would compensate for putting up with it at all." They dissolved the team later in the year.

8
WILBUR'S DEATH

In the hilly, tree-shaded suburb of Oakwood just south of Dayton, a Colonial-style mansion overlooks its neighbors in quiet splendor. No brown signs or public parking lots mark it as an element of the Dayton Aviation Heritage National Historical Park. Its neighbors want it that way. But an act of Congress in 2009 added Hawthorn Hill to the national park's collection of Dayton-area sites that tell the story of the Wright brothers.

Hawthorn Hill is intimately related to their story, but it stands apart from the other sites. Hawthorn Hill isn't about airplanes but about family. Wilbur, Orville and Katharine were to live there with their father just as they had at 7 Hawthorn. While the elder brother had a hand in the planning of Hawthorn Hill, he didn't live to see it built. The bishop lived there until his death in 1917. Katharine lived there until 1926, when she married Henry J. Haskell, an old college friend, and moved to Kansas City. Feeling abandoned, Orville refused to see her until she was on her death bed with pneumonia in 1929. He lived on at Hawthorn Hill until his death in 1948.

Hawthorn Hill was the most visible sign of the wealth the Wright brothers gained from their airplane and the change it made in their lives. The Wright family home at 7 Hawthorn was comfortable, but the small, narrow house was hardly suited to entertaining world leaders. Soon after forming their company and acquiring wealth, the Wrights decided to make a home that reflected their new station in life. They bought a parcel on the north side of town at Salem and Harvard, but Katharine wanted a place with more privacy. In February 1912, they bought a seventeen-acre lot in Oakwood dominated by a hill shaded with hawthorn trees. On the top of the hill they built a mansion.

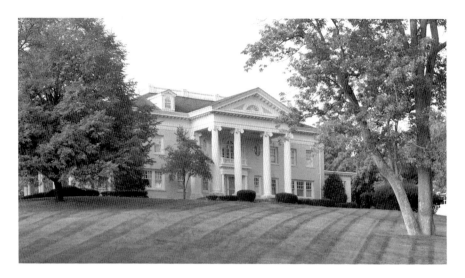

Hawthorn Hill, the Wright family mansion, catches early morning light in September 2013. *Author's photo.*

Although he consulted with his family, Orville made Hawthorn Hill his personal project. Construction began in 1912; when it was finished in 1914, Orville and Katharine spent four days in Grand Rapids, Michigan, picking out furnishings at Berkey & Gay Furniture Company. Orville equipped the house with many laborsaving devices, some of his own invention. He designed the utility systems himself, including one that collected and filtered rainwater for bathing. In *The Bishop's Boys*, Tom Crouch called Hawthorn Hill "Orville's machine for living." The family moved in on April 28, 1914.

No doubt the high ground gave them a sense of security. A year earlier, the Great Dayton Flood had ravaged the city, killing hundreds and doing major damage to homes, shops and factories. Surging into West Dayton on March 25, the water swept into the Wrights' neighborhood, eventually inundating 7 Hawthorn to a depth of six feet. As the waters gushed in, the Wright children helped their father evacuate in a neighbor's canoe. "The flood was second to Noah's," the bishop wrote in his diary.

The flood ruined their old space in the Speedwell plant and eventually put the carmaker out of business. Two miles west of the river on higher ground, the Wright Company factory was safe. But the flood swamped the bicycle shop. "It has now been two and one-half weeks since I have been able to be in my office and we have not yet succeeded in getting any light or heat," Orville wrote to Andrew Freedman on April 11. Besides the shop, the boxed-up flyer, photographic negatives and other priceless historic records were

From left: John R. McMahon, Pliny Williamson; Orville, Milton and Katharine Wright; Earl N. Findley; and nephew Horace Wright at Hawthorn Hill. *Papers of Wilbur and Orville Wright, Prints and Photographs Division, Library of Congress.*

immersed; many records were lost or damaged. Today, some of the famous photos of the Wright brothers' flights show the marks of water-damaged emulsion. Back in New York, Wright Company directors agreed to donate $5,000 to Dayton's recovery efforts.

The Wright brothers had vowed to rest the burdens of corporate life on managers while they resumed the joyous process of invention and discovery. But they continued to manage every aspect of the company. Orville focused on company operations while Wilbur continued to wage the patent fights and oversee the foreign companies. They did little research together, if any.

Orville thought the unending patent dispute wore down his brother. "The delays were what worried him to his death…first into a state of chronic nervousness, and then into a physical fatigue," Orville said years later. Returning from a trip to Boston on May 2, Wilbur fell ill. While he seemed to get better at first, he developed a high fever on May 4. He seemed stable

A memorial service at the Wright family grave site in Woodland Cemetery on June 1, 2012, marked the 100th anniversary of Wilbur's death. Neil Armstrong spoke at the service. *Author's photo.*

enough for Orville to leave for Washington to deliver an airplane, but Wilbur became unconscious two days later.[1]

Orville rushed home. Two local doctors and a specialist from Cincinnati treated Wilbur. Nurses cared for him around the clock. Local newspapers made daily reports about his condition. Wilbur died on May 30. He had just turned forty-five in April. "A short life, full of consequences," Milton Wright wrote in his diary. "An unfailing intellect, imperturbable temper, great self-reliance and as great modesty, seeing the right clearly, pursuing it steadily, he lived and died."[2]

Dayton, America and Europe grieved. More than one thousand condolences flooded the Wright home. Newspapers around the world published tributes. On June 1, the day of his funeral, Wilbur's body lay in state from late morning until early afternoon in the First Presbyterian Church downtown. Thousands lined up to pay their respects. The funeral service took place at 3:00 p.m. At 3:30 p.m., all the city's church bells rang and streetcars, trains and interurbans paused for five minutes. Wilbur was laid to rest in Woodland Cemetery. A century later, a memorial service at Wilbur's graveside would include remarks by another pioneer aviator and fellow Ohioan: Neil Armstrong, engineering test pilot and the first man to walk on the moon.[3]

9
ORVILLE'S COMPANY

N ow Orville was left to run the company and defend its patents without his older brother. Faced with the biggest loss in his life, he seemed unable to act. The company's directors wanted to see new products and a stronger sales program. But correspondence and Wright Company board minutes indicate Orville wasn't attending board meetings and was doing little to develop new airplanes. It took him more than a year to hire a replacement for Frank Russell.

Some believed Orville's inaction resulted at least in part from personal struggles. Grover Loening, the young aeronautical engineer Orville finally put in Russell's place, thought Orville "seemed somewhat lost" in the wake of Wilbur's death. Before Loening reported to Dayton in July 1913, Alpheus Barnes met with him in New York and warned him Orville seemed all but unable to make decisions without his elder brother. According to Loening's book *Takeoff into Greatness*, Barnes told him, "Ever since Orville succeeded him as president, we really have no boss."

Loening also learned Orville's sciatica, his old injury from the Fort Myer crash, was flaring up and wearing him down. The truth was probably even worse, given Orville's undiagnosed hip injuries. Travel and even standing for very long was tiring and painful—another reason to loathe bumpy train rides to New York for company business.

Orville might have been following his late brother's business strategy. Wilbur never seemed under the illusion that airplanes could become a volume business. Back in Paris in 1907, his advice to Orville and Hart Berg had been to "sell few machines at a big profit."[1]

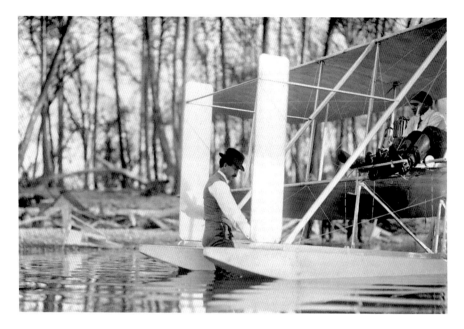

Orville Wright stands in the Great Miami River south of Dayton with a Wright Model CH Flyer. *Courtesy of Special Collections and Archives, Wright State University.*

But their loss of the injunction against Curtiss in 1910 meant the Wright Company couldn't control the marketplace. Wilbur saw no hope for growing the company and paying off their investors as long as the patent suit remained unresolved. An economic recession that gripped the country throughout 1910 and 1911 must have been discouraging as well. "Their chance to make a big profit vanished when the injunction was dissolved," he wrote to Orville on June 30, 1911. He suggested what amounted to a survival strategy: cut costs to the bone and simply "keep the company financially sound till our competitors are 'busted.' Then our company can do a modest business sufficient to pay reasonable interest and our responsibility [to investors] will be ended." Wilbur made his gloomy assessment even as the company was finishing its second factory building.

The Wright Company had folded its exhibition department, but former Wright exhibition pilots and other celebrities continued to die conspicuously, many in Wright airplanes. Cal Rodgers died in April 1912. Parmelee died on June 2 in North Yakima, Washington, before an exhibition crowd that included his fiancée. Al Welsh and his passenger, Lieutenant Leigh Hazelhurst, died nine days later. Howard Gill died in September 1912, when another plane struck his during a pylon race at Cicero Field in Chicago.

Arthur L. "Al" Welsh and George William Beatty at the Wright Flying School on Long Island in 1911. *George Grantham Bain Collection, Prints and Photographs Division, Library of Congress.*

Even Huffman Prairie wasn't immune to the carnage. Fred J. Southard, an apparently hopeless student from Minneapolis who had bought his own airplane, grew defiant after weeks of hearing instructors tell him he wasn't ready to solo. Early on May 21, 1912, he stole onto the prairie and broke into the hangar. He rolled out his airplane, fired it up and took it aloft—promptly stalling and stuffing it into the ground.[2]

The Wright Company's directors didn't help matters. In the wake of Wilbur's death, they elected Orville president in June—with the request "to not do any flying, at least for the present," Orville informed Alger in a June 26 letter. Leaked to the press, the board's sudden fear of flying "had about as detrimental an effect upon amateur flying as anything I have seen," Russell Alger observed in a July 1 reply to Orville.

The death toll continued to climb. In an article on October 16, 1912, the *New York Times* reported two hundred fatal mishaps worldwide, with the United States second only to France in aviation mortality.

On October 26, Orville told Alger the string of fatal accidents "had a very depressing effect on the business this year. We had a number of sales practically completed which were lost as a result of the accidents." Thanks to government sales, Orville predicted a third year of dividends for the company's stockholders, but he added, "I think it quite probable

that for the next year or two, we will have to depend almost entirely on the government business."

To at least some company directors, the one bright spot in the civilian market was floatplanes. Curtiss's floatplanes were catching on among wealthy sport pilots, and the government was showing interest as well. Alger had been doing his own floatplane experiments since 1911. The next summer, Barnes made arrangements to open the floatplane school at the Glenwood Country Club. Freedman hoped getting into the floatplane business would show the Wright Company was still a force in the market. He was urging Barnes, he told Orville in a July 26 letter, to push the floatplane school "in order that it will not appear that we have lost interest in the development of aviation."

Orville wasn't ignoring the floatplane market, or the development of new products. Before Wilbur's death, he had been working on a number of advancements that applied to floatplanes—from retractable wheels, innovative stepped floats and auxiliary starters to a muffled six-cylinder engine, an automatic stabilizer and an angle-of-attack gauge. The company offered its unique floats alone or as an option on the Model B.

But its entry into the floatplane market was a fiasco. At Glen Head, Wald—sent there directly from the Huffman Prairie school with no floatplane

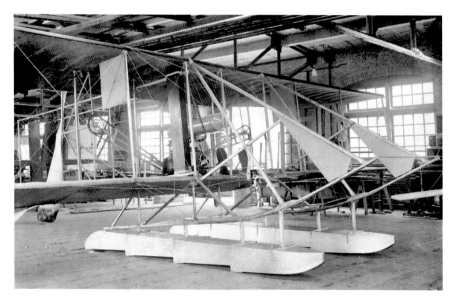

A Wright Model B Flyer with twin, multi-step pontoons in the Wright Company factory. *Courtesy of Special Collections and Archives, Wright State University.*

experience—made just thirteen flights before flipping over in the water and nearly drowning himself and his passenger. The Glen Head school closed without selling a flying lesson or an airplane.[3]

It didn't end the company's interest in floatplanes. Orville began testing floatplanes on the Great Miami River south of Dayton near Sellar's Road, not far from where Moraine Air Park is today. (Along the bicycle trail that skirts the east bank of the river in West Carrollton, you can find a wayside sign that marks the site of what a nonprofit group of the same name calls the "Wright Seaplane Base.")

Orville also hired Grover Loening, a young engineer with some floatplane experience. Loening had become the first engineering student in the country to receive a master's degree in aeronautics. After graduating from Columbia University, he had worked for a small New York airplane company and experimented with a flying boat of his own design. He had been corresponding with the Wright brothers since 1910 and inquiring about a job since 1911. Orville gave him Frank Russell's old job.

By the time Loening came on board, Orville was completing the Wright Company's first dedicated floatplane model, the C-H. Initially it had long, twin pontoons, but testing revealed handling problems in the air. The final version had a single, ten-foot by six-foot wooden pontoon mounted under the runners, with small pontoons under the wingtips and tail. Although photos and drawings show only seats for two, aviation journals reported Orville flew the C-H with as many as three passengers, including his assistant "Taylor"—presumably Charles—as well as Taylor's son and another adult.

But the C-H followed the general pattern of the original Kitty Hawk flyer of 1903: the pilot rode in the open between two wings. Well before the C-H came out, Curtiss was flying seaplanes, or "flying boats"—aircraft with boat-like hulls instead of floats. The November 2012 issue of *Aeronautics* predicted, "Yachting with the flying boat is destined to be the greatest of sports." The C-H was outdated before the first one left the factory.[4]

Loening defended the C-H in the September 1913 issue of *Aircraft*, praising it as an airplane "of remarkable efficiency and airworthiness" while criticizing flying boats—even as he worked on his own flying boat design for the Wright Company. By the following June, he was hailing the new Model G Aeroboat as "exceedingly boat-like in appearance."[5]

Visually, the G was a striking departure from earlier Wright airplanes. The hull enclosed the engine in its nose and partially enclosed the side-by-side occupants. In a first for the Wright product line, it offered a control wheel as an option to the traditional levers. But the Aeroboat still used the Kitty

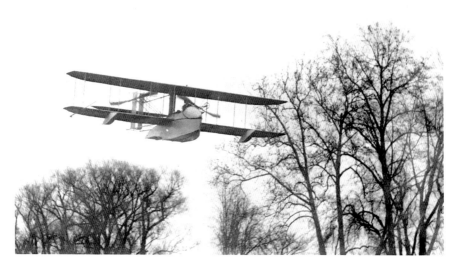

A Wright Model G seaplane over the Miami River, circa 1914. *George Grantham Bain Collection, Prints and Photographs Division, Library of Congress.*

A wheel-type control system on a Wright Model G Flyer. *Courtesy of Special Collections and Archives, Wright State University.*

Hawk–style propulsion system—chain driven pusher propellers, turned by a long drive shaft that ran under the seats. One innovation was a flexible drive coupling to reduce vibration and wear on the long shaft.[6]

It isn't clear how much influence Loening had on the company. He stayed only a year. In *Takeoff into Greatness*, Loening wrote he found himself caught between two imposing company officers—Orville and Barnes, who began making extended visits to the Wright Company factory after Wilbur's death. Barnes had little regard for Orville or what he called "these Ohio hicks," according to Loening; Orville considered Barnes a meddling nuisance. Sensing that anything he did to please one boss would anger the other, Loening left in July 1914 to become chief aeronautical engineer for the Army's Aviation Section.

As the aviation industry developed, the Wright Company's product line fell rapidly behind the state of the art. Every Wright airplane was a derivative of the original flyer, with warping wings and chain-driven pusher propellers, while the market began to favor tractor propellers, ailerons and other refinements. Most damaging to the company was the notorious Model C.

The Model C was essentially a Model B with a more refined design and a more powerful engine. The Wright Company sold five Model Cs to the army as "weight carriers," able to carry a pilot, a passenger and enough fuel for a four-hour flight. Welsh and Hazelhurst died while testing the first one at College Park; the Wright Company furnished a replacement.

Their crash was just the beginning of a grim period for the Wright Company. Between September 1912 and February 1914, eight army officers died in seven Wright airplanes—two Model Bs and five Cs. A non-fatal crash destroyed another Model C in 1913. In less than two years, the army lost all six Model Cs in crashes, and in that period the Model C alone accounted for half of all army pilot fatalities in heavier-than-air machines.[7]

The death rate alarmed the army. Orville, while calling the loss of life "most distressing," didn't think it was out of proportion to death rates in France or Germany. He also maintained that "more than ninety percent" of the crashes resulted from stalling. In a December 5, 1913 letter to Lieutenant Colonel Samuel Reber, Orville defended the Model C as "the best machine and the safest machine we have built," but that its greater power and maneuverability "tend to make the aviators careless" about avoiding stalls.

But an army board recommended limiting flying operations to certain airplanes, all tractor-propelled types—in effect condemning all Wright airplanes, since they all used pusher propellers. At the same time it opened the door to fledgling California airplane maker Glenn L. Martin. With many

of its airplanes crashed or grounded, the army turned to Martin to supply tractor-type training planes. Martin would prosper and eventually merge his business with the Wright Company.[8]

Orville claimed the army could "positively eliminate" nearly all the stalls its aviators were experiencing if they simply used a new device his company had introduced in 1913. It was the incidence indicator, an early angle-of-attack gauge whose sole purpose was to help pilots avoid stalls. The device used a simple air vane to move an arm on a dial, and it could be mounted on a wing strut where the pilot could see it. The idea seemed to draw limited interest at the time, but eventually angle-of-attack sensors with displays in the cockpit would become essential equipment in military and transport aircraft. In 2014, the Federal Aviation Administration strived to encourage more pilots to use angle of attack indicators by simplifying its rules for installing them in private airplanes.[9]

Another safety device the company introduced was the automatic stabilizer, which used a pendulum to sense if an airplane was tilting in pitch or roll and automatically adjusted the controls. The Wright brothers had worked on the design for years, applying for a patent in 1908. The Patent Office finally granted it in October 1913. After Orville demonstrated it on Huffman Prairie on December 31, 1913, the Aero Club of America awarded him its coveted Collier Trophy. In January 1914, Orville told the *New York Times* the stabilizer would "revolutionize flight" after it became available in the spring.

But Orville was wrong. In 1913, Lawrence Sperry, the son of Sperry Gyroscope founder Elmer Sperry, developed a gyroscope-based stabilizer for airplanes. A Curtiss flying school graduate, Sperry tested his invention in a Curtiss flying boat and flew it to win an Aero Club of France prize in 1914. It was a true breakthrough in the fields of stabilization and guidance, making long-distance flight and "blind flight" in clouds more practical. It instantly outdated the Wright device.[10]

On January 13, 1914, the U.S. Second Circuit Court of Appeals handed down its long awaited decision. It upheld the Wright patent. The decision echoed Judge Hand's conclusion that the Wright brothers were "pioneers in the practical art of flying with heavier-than-air machines and that the claims should have a liberal interpretation." Courts in Germany and France also eventually ruled in favor of the Wright brothers.

"This will give us an absolute monopoly, as there are no machines at the present time that do not infringe this claim," Orville wrote to Andrew Freedman a week after the decision. Alpheus Barnes was ecstatic. "I feel sure things will now begin to hum," he wrote to Loening on January 16.

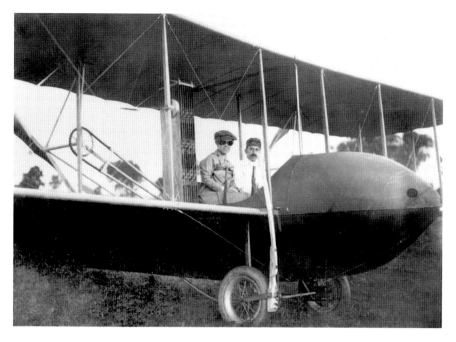

Katharine and Orville in a Model H Flyer. *Courtesy of Special Collections and Archives, Wright State University.*

Loening knew what Barnes had in mind. "Barnes would daydream with me of what it would mean if the Wright Company were to win the suit," Loening recalled in *Our Wings Grow Faster*. The company was poised to create a monopoly like that of Bell Telephone. "There were untold millions of dollars ready in New York to be invested in such a trust," Loening wrote. Curtiss and the rest would be shut down or bought up, and the Wright Company would rule the industry.

But this wasn't Orville's idea of a monopoly. "With the winning of the suit, his revenge on Curtiss seemed satisfied, and all he wanted was tribute—royalties from everyone," Loening wrote.

All along, the Wright brothers' strategy had been to license manufacturers and collect a hefty 20 percent royalty for every machine produced, or about $1,000 on the typical $5,000 price of an airplane in those days. They intended to collect on every airplane produced because every airplane fell under the broad definitions in their patent. A few manufacturers, notably Burgess-Curtis, Inc. and Glenn Martin, paid licensing fees.

Curtiss tried to dodge the ruling by disconnecting the ailerons to make them operate separately. When Orville sued Curtiss again, Curtiss sought

to make the case that the Wright flyer wasn't the first machine capable of flight. As evidence, he claimed Langley's *Aerodrome*, the houseboat-launched machine that had failed to fly in 1903, could have done so. Hoping to vindicate its late director, the Smithsonian loaned what remained of the *Aerodrome* to Curtiss and granted him $2,000 to restore and fly it. After major modifications, Curtiss coaxed the machine into the air for a few seconds. The Smithsonian put the modified *Aerodrome* on display, proclaiming it as the first airplane capable of flight. The Smithsonian's support of Curtiss outraged Orville and sparked a feud that kept the 1903 Wright Flyer out of the Smithsonian until after his death.

With the patent tied up in court again, Curtiss continued to produce airplanes under the Curtiss Aeroplane Company. The unending litigation tarnished the Wright brothers' reputations. While they enjoyed support from the hometown press, news coverage elsewhere was more critical. Even some historians describe the Wright brothers' aggressive enforcement of their patents as "litigiousness." And some critics blamed the patent suits for slowing American advancement in aviation. Nearly a year after the 1914 decision, a December 18 article in the *New York Tribune* complained that the industry's dormancy continued because the "Wright-Curtiss fight has prevented manufacturers from extending their business and retarded development" throughout the United States.[11]

Orville had made the same point as the *Tribune* just after the decision. A *New York Times* article said he called the long dispute with Curtiss "the one great cause for America's continued backwardness in aviation development." But Orville said it was the prospect of having to wage expensive legal marathons to enforce their patents, not a threat of monopolization, that deterred inventors from bringing out new ideas. Had the injunction handed down in 1910 held, "aviation would be upon a settled and stable basis," the *Times* quoted him as saying.

Orville predicted the decision would allow aviation to advance rapidly. He told the *Times* he would soon introduce many improvements he had been keeping secret.

The improvements didn't come right away. The 1913 Model F, built for the army, essentially was another Wright flyer with a fuselage. It featured a boat-like body with a metal shroud over the nose-mounted engine. The original design, credited to Loening, included two tractor propellers in front of the wings and tandem seating. But the model delivered to the army reverted to side-by-side seating and pusher propellers for better visibility. A review in the November 20, 1914 issue of the British journal *Flight* called it "still the

Wright biplane of old." The army dubbed it the "Tin Cow." Oscar Brindley, a former Wright Company pilot who was working as a civilian instructor for the army, said it handled badly. The army accepted it but dropped it from its inventory in June 1915 after only seven flights. It was the only Model F the Wright Company built.[12]

But in 1914, the Wright Company's product line began to change, and in just two years it cast aside the traditional Wright flyer features. That year it introduced its first seaplane: the Model G Aeroboat. While it retained the chain-driven pusher propellers and warping wings, the Aeroboat featured a stepped hull, nose-mounted engine and optional control wheel. The 1914 Model H and the slightly smaller 1915 HS had nose-to-tail wooden fuselages. The 1915 Model K seaplane was the first Wright airplane with ailerons and tractor propellers, although it still used the 1903-style chain drive. According to Roach, the single Model K the Wright Company delivered to the navy was the company's only recorded sale of that model, although the navy had planned to buy up to nine aircraft. It was also the Wright Company's last government sale.

Last came the Model L, developed as a military scout. The single-propeller, direct-drive tractor design had a box-shaped fuselage, squared-off

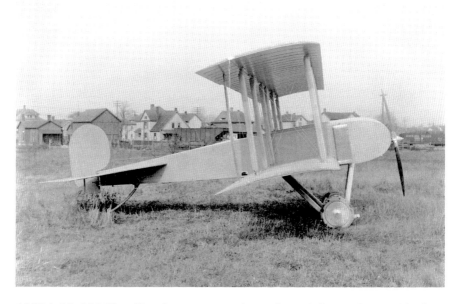

A Wright Model L Flyer. Note the nose-mounted propeller and ailerons. *Courtesy of Special Collections and Archives, Wright State University.*

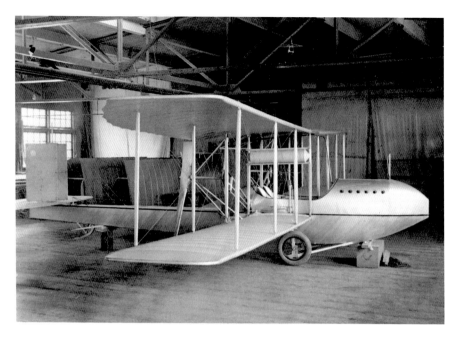

A Wright Model F Flyer sits in the Wright Company factory. *Courtesy of Special Collections and Archives, Wright State University.*

wings, ailerons and a swiveling tailskid. It made a complete break from the traditional Wright airplanes, and it may have reflected many of the changes Orville hinted at in 1914. But it didn't roll out until 1916, after Orville had sold the company. And it failed to close the gap with the competition.[13]

The patent decision seemed to have little real impact on the Wright Company's fortunes. Competitors continued to sell airplanes in growing numbers while the Wright Company's production atrophied. A July 1915 Signal Corps report found Curtiss's Buffalo plant led the industry in production, turning out 3 airplanes every two days on average. Burgess, by then a Curtiss subsidiary, was producing 15 to 20 airplanes per month in Marblehead. Martin was producing 10 a month in Los Angeles, and Thomas Brothers (later the better-known Thomas-Morse) was rolling out an equal number in Bath, New York. In contrast, the Wright Company factory's entire output from the time it opened was only about 120 airplanes, according to an estimate by Orville in June 1915.[14]

The great monopoly of the Wright Company directors' dreams simply never materialized. It "did not happen because of one man—Orville Wright," Loening wrote in *Our Wings Grow Faster*. "He did not want to

expand. He fought the New York interests." Orville stymied the New York directors and then borrowed money to buy them out—all except Collier, a personal friend, who kept a 3 percent share of the company. The next year, Orville sold the company to a group of New York financiers, signing the deal on October 15, 1915. They didn't disclose the selling price, but the October 14 *New York Times*, citing unnamed sources, initially reported it fetched $1.5 million. A November 16 article downgraded it to $500,000, plus a $25,000 annual salary to Orville as a consultant.

The Wright Company's order book was empty, and its manufacturing capacity was unchanged from 1911. Its greatest value was the patent, which remained in force despite Curtiss's legal maneuvering. It was a force the new company intended to use. "The new company will not hesitate to prosecute infringements of the patents," it said in a statement reported in the *Times*'s October 14 article.[15]

For the Wright Company, it was the first in a series of acquisitions that would lead to the greatest irony in the history of aircraft manufacturing. In 1916, the Wright and Glenn L. Martin companies merged to form Wright-Martin Aircraft. It also purchased the Simplex Automobile Company. Glenn Martin left to form a new Glenn L. Martin Company in Cleveland in 1917, and Wright-Martin changed its name to the Wright Aeronautical Corporation in 1919. It ended airframe production to concentrate on engines, and a decade later it merged with the Curtiss Aeroplane and Motor Company, creating—incredibly—the Curtiss-Wright Corporation. The New York–based company organized its product lines into two main divisions, with engines and propellers under Wright and aircraft under Curtiss. The Curtiss division had many other units as well. Curtiss-Wright is a much different company today, but it sustains the legacy of the two greatest names in American aviation history.

Aviation activity in Dayton faded, according to Roach in *The Wright Company*. The company's new owners phased out manufacturing in the Dayton plant in 1916 and closed the flying school on Huffman Prairie. Only some experimental work continued in the factory until the Wright-Martin Company closed the plant in February 1917.

The U.S. aviation industry languished compared to the rapid growth and advancement in European countries. The reason had nothing to do with the Wright patents; the European powers and Great Britain were funding research, development and manufacturing in preparation for war. When the fighting began in 1914, Germany's budget for military aviation was $45 million, Russia's was $22.5 million, France's was $12 million and Great

Britain's was just over $1 million. In contrast, the 1915 appropriation for U.S. Army aviation was $250,000. Its fleet numbered twenty-three airplanes.

America entered World War I in April 1917 with an army fleet of 132 airplanes, none combat-ready. Politicians and pundits raised a national outcry over the nation's lack of air power. Government funding for aircraft production exploded. The 1917 aviation act included $640 million for army aviation—roughly $15 billion in 2014 dollars. But manufacturers balked,

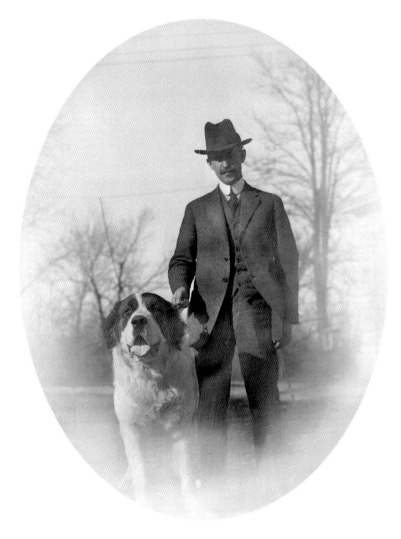

Orville with his beloved pet Scipio. Orville acquired the St. Bernard in 1917. *Papers of Wilbur and Orville Wright, Prints and Photographs Division, Library of Congress.*

pointing to the still unsettled patent situation. At the government's urging, the principal aircraft manufacturers came together and within weeks hammered out a cross-licensing deal for aviation patents. They assigned its management to a new industry group, the Manufacturers Aircraft Association (MAA). In a nutshell, the deal allowed association members to produce airplanes for a modest licensing fee. The MAA's first president was the former Wright Company manager, Frank Russell.[16]

Almost in the blink of an eye, the costly, years-long legal fight over the Wright airplane patent ended. Without the urgency of war, the patent dispute might have dragged on a few more years until the patent expired. But without the sudden flood of government dollars for military aircraft, it isn't clear what difference it would have made. In the long run, if Orville was right about the toll the patent war took on his brother, then its biggest impact on aviation progress might have been in causing Wilbur's untimely death and ending the Wright brothers' historic collaboration.

With the company sold, Orville moved out of the bicycle shop and into a new laboratory at 15 North Broadway Street, just off West Third. The single-story brick building had a large workroom and an office. Orville equipped it with a wind tunnel and designed instruments similar to those of the 1901 tunnel, which he considered superior to those in use by other research labs.

Orville wasn't quite out of the aviation business. Edward Deeds, Dayton industrialist and Orville's friend, had formed the Dayton Engineering Laboratories Company (DELCO) with Charles Kettering and the Dayton Metal Products Company with Kettering and the Talbotts, Harold Senior and Junior. When Wright-Martin exited Dayton, Deeds and his friends formed the Dayton Airplane Company. They recruited Orville as a director and consulting engineer and renamed it the Dayton-Wright Airplane Company.

With America's entry into World War I, the sudden flood of military dollars rejuvenated Dayton's aviation industry. But Deeds, not Orville, was the force behind it. Deeds had powerful military and political connections, and he soon had a commission as army colonel and an assignment as head of aircraft procurement. He cut his financial ties with Dayton-Wright and awarded massive production contracts to the company—a practice that led to calls for his court-martial but not formal charges. Dayton-Wright produced thousands of airplanes at its Moraine plant and acquired two more plants to produce parts. One was the old Wright Company factory. Deeds also persuaded the War Department to establish an army aviation

training field, a supply depot and the army's aeronautical research center in the Dayton area—major military missions the army eventually centralized at Wright-Patterson.

Although he was mainly viewed as a figurehead for Dayton-Wright, Orville conducted research for the company. In 1924, he shared an aviation patent for the split flap with a former Wright Company employee, James M. H. Jacobs. In later years, memories of the patent war faded. The aviation industry, America and most of the world revered Orville and the memory of Wilbur for their pioneering work. Orville lived quietly at Hawthorn Hill and worked in his laboratory until his death from a heart attack on January 30, 1948. He was seventy-seven.

RECLAIMING HERITAGE

I t's all but impossible to visit Dayton and not run into reminders of its aviation heritage. Countless institutions have made Wilbur and Orville their namesakes, such as Wright-Patterson Air Force Base, Wright State University, Wright Library and Dayton-Wright Brothers Airport. Two original Wright airplanes are on display, and the area sports more than a half dozen full-scale replicas and sculptures of gliders and flyers.

For all that, Dayton still struggles to reclaim its heritage.

Just as Daytonians allowed the Wright brothers to work on Huffman Prairie in near anonymity more than a century ago, the community has been remarkably nonchalant when it comes to reminding the outside world of its rich heritage. As a result, people tend to associate the Wright brothers with North Carolina, not Ohio or Dayton. A nationwide awareness survey conducted in 2005 by the Aviation Heritage Foundation, a Dayton-based nonprofit, found 80 percent of the population knew the Wright brothers invented the airplane, but only 14 percent knew they invented it in Dayton, while 40 percent believed they invented it in North Carolina.

Ideas for a memorial to the Wright brothers in Dayton surfaced as early as 1910. A short article in the February 10 *Dayton Daily News* that year reported on a rumor of plans to commemorate the Wright brothers' 1905 flights on Huffman Prairie. Civic leaders in 1912 considered a number of proposals. Most ambitious was a concept for a memorial science museum to be built near Simms Station, coincidentally less than three miles from where the

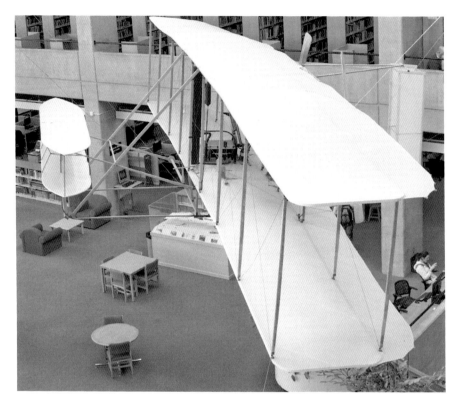

This full-scale model of the 1903 Wright Flyer hangs in the atrium of Wright State University's Dunbar Library. *Author's photo.*

National Museum of the U.S. Air Force stands today. Nothing materialized. Other plans for memorials came and went over the years.[1]

Civic leaders in North Carolina started working on plans for a national memorial on the Outer Banks in the 1920s. They saw it as a way to showcase the state's role in the Wright brothers' accomplishments and boost tourism on the Outer Banks. State and federal officials dedicated the Wright Brothers National Memorial in 1932. The National Park Service acquired it in 1933 and continued to expand it. The project coincided with construction of the first bridge between the mainland and the Outer Banks.[2]

Meanwhile, Daytonians had converted their Wright heritage into an industry and an important part of the region's economy. Wright-Patterson Air Force Base and other institutions memorialized the Wright name. Civic leaders formed the National Aviation Hall of Fame in 1962 and persuaded Congress to charter it in 1964; its first two enshrinees were Wilbur and

A C-5 Galaxy from Wright-Patterson Air Force Base passes over the Wright Memorial in 2008. The hilltop memorial overlooks Huffman Prairie. *Author's photo.*

Orville. But plans for a memorial place languished, and Dayton showed scant interest in preserving the places where the Wright brothers had lived and worked.

This neglect came at the same time racial segregation was concentrating Dayton's black population in West Dayton. In response to a 1923 policy barring African Americans from downtown theaters, the Classic Theater opened in 1926 on West Fifth Street between Horace and Mound. Its opulent marble lobby, ballroom and pipe organ helped make West Fifth "the center of black life," according to Margaret E. Peters's *Dayton's African American Heritage*. African American businesses flourished along West Fifth Street. By 1940, 84 percent of Dayton's black residents lived west of the river. West Dayton declined, especially after race riots in the 1960s drove away business investment. Historic buildings deteriorated, their connections to the Wright brothers largely forgotten.

In 1936, Henry Ford bought the old Wright Cycle Co. building at 1127 West Third and the family home at 7 Hawthorn. He had them taken apart and reassembled in Greenfield Village, his collection of historic structures in Dearborn, Michigan. Ford's acquisition jolted Daytonians. Edward Deeds spearheaded the Wright Memorial Commission to create a memorial

This replica façade stands on the site of Orville Wright's laboratory in the Wright-Dunbar neighborhood. *Author's photo.*

park on a hilltop overlooking Huffman Prairie. Senior military officials and community leaders dedicated the Wright Memorial in a ceremony on August 19, 1940—Orville's birthday and, as of the previous year, National Aviation Day. Orville attended, along with then Major General Hap Arnold and other aviation pioneers who had learned to fly on the prairie.[3]

The first efforts to preserve local sites associated with the Wright brothers came in the late 1940s. Deeds launched a project to restore the 1905 Wright Flyer III and build a special hall for it at Carillon Historical Park. After Orville's death, National Cash Register (now known as NCR) acquired Hawthorn Hill and preserved it as a VIP guest quarters.

After Ford acquired the bicycle shop and family home, a feature story in the July 12, 1936 *Dayton Journal* showed photos of Wright sites that were still standing, including Orville's laboratory and the Wright Company hangar on Huffman Prairie. But the buildings languished. The hangar continued to deteriorate until it was torn down at some point after World War II.

The saga of Orville's laboratory is especially sad. In 1972, Standard Oil Co. of Ohio bought the property for a filling station to be built at the corner of West Third and North Broadway. Standard Oil delayed demolition for several years, offering the building and $1,000 to anyone who would take it. But community groups failed to stir much interest or raise enough money

to relocate the building to another site. Standard Oil tore down Orville's laboratory in November 1976, preserving the façade and giving it to Wright State University. It never built the gas station.[4]

But a grassroots effort was sprouting to preserve and promote the region's aviation heritage. In 1973, an informal group of individuals at Wright-Patterson decided to build a flyable lookalike of the Wright brothers' first production airplane—one built to modern standards so they could fly it at air shows and other events. They launched the project in 1975 and formed the nonprofit Wright "B" Flyer, Inc. to support it. The one-of-a-kind lookalike has been flying since 1982.

By 1980, a growing loss of manufacturing jobs prompted Dayton to look for ways to bolster its economy. Aviation Trail Inc. (ATI), incorporated in 1981 as a nonprofit dedicated to preserving the region's aviation heritage, raising awareness of the region's place in aviation history and stimulating the economy through aviation-related capital projects. ATI identified numerous historical aviation sites, identified them with markers and produced a guidebook, *A Field Guide to Flight*.[5]

In their research, ATI members discovered one Wright Cycle Co. building still existed in Dayton—the one at 22 South Williams. The organization

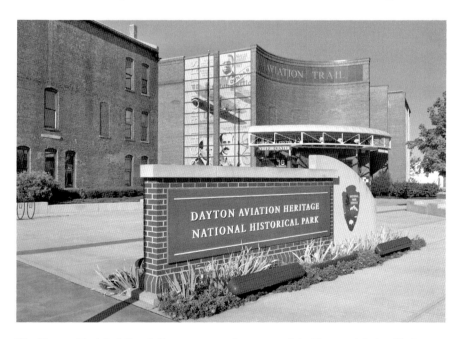

The Hoover Block building (left) was renovated as a part of the Dayton Aviation Heritage National Historical Park's Wright-Dunbar Visitor Center. *Author's photo.*

raised money to save the building from demolition and restore it as a public attraction. ATI also worked to preserve the nearby Hoover Block. These projects helped spur a broader community effort to restore the Wright brothers' neighborhood and establish a national historical park. The effort grew as the Dayton region began planning for the centennial celebration of powered flight in 2003. Community leaders pressed Ohio's congressional delegation to pass federal legislation to establish a national park.

The Dayton Aviation Heritage National Historical Park opened in 1992, originally with four sites—Huffman Prairie Flying Field, the Wright Flyer III at Carillon Park, the Wright Cycle Company shop at 22 South Williams and the Paul Laurence Dunbar State Memorial. NCR returned Hawthorn Hill to the Wright family in 2006, and in 2009 President Obama signed legislation expanding the national park's boundary to include Hawthorn Hill and the Wright Company factory site. Dayton History acquired Hawthorn Hill and began offering tours of the home to small groups on a regular schedule. The Wright Company site was active as a part of the Delphi Home Avenue manufacturing plant until Delphi closed the plant in 2008. A redevelopment company acquired the site in 2012 and was completing the demolition of non-historic buildings in 2014, but the factory remained closed to the public.

The federal legislation that established the park also established the Dayton Aviation Heritage Commission to support the park's development and chart a long-term strategy for preserving and promoting aviation heritage in the region. A "sunset" provision designed to keep the commission from becoming a permanent federal bureaucracy required it to find a non-government successor to carry out the strategy by the end of 2003. It formed what's now known as the National Aviation Heritage Alliance (NAHA), a nonprofit organization.

NAHA advocated for the creation of a U.S. National Heritage Area, which would be eligible for federal funding and technical assistance from the National Park Service. In 2004, Congress established an eight-county region surrounding Dayton as the National Aviation Heritage Area and designated NAHA as its management entity. NAHA works in partnership with the National Park Service, the National Museum of the U.S. Air Force and numerous large and small aviation heritage partners. Its board also includes representatives of the tourism and aerospace industries. NAHA's vision is for the Heritage Area to be the recognized center of aviation heritage tourism and aerospace innovation, sustaining the legacy of the Wright brothers. As this book went to press, NAHA was working with the National Park Service, the private developer Home Avenue Redevelopment LLC, the City

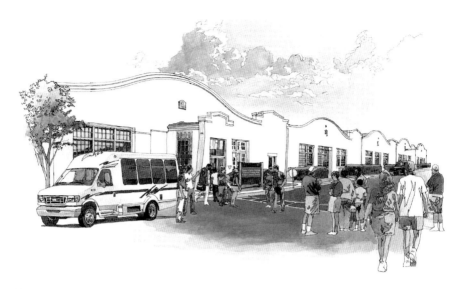

This artist's rendering shows how the Wright Company factory might look as a unit of the Dayton Aviation Heritage National Historical Park. *Courtesy of the National Aviation Heritage Area.*

of Dayton and others to secure and restore the Wright Company factory site. Once in the hands of the National Park Service and open to public visitation, the Wright Company factory site will complete the story of the Wright brothers in Dayton and the birth of America's aerospace industry.

WRIGHT SITES

DAYTON AVIATION HERITAGE NATIONAL HISTORICAL PARK

Website: http://nps.gov/daav

Hawthorn Hill

Location: Oakwood. Hawthorn Hill is the Wright family mansion where Orville lived until his death in 1948. Dayton History manages the home and makes it accessible by scheduled tours from Carillon Historical Park.

Huffman Prairie Flying Field

Location: Gate 16A, Wright-Patterson Air Force Base. Huffman Prairie Flying Field is where the Wright brothers continued their flying experiments after 1903 and demonstrated practical flight in 1905. A replica shed, tower and launching track represent their experimental work. The field also includes an outline of the Wright Company's hangar and a replica of the Simms Station platform nearby. Next to the flying field is a remnant of a native Ohio tall grass prairie. Huffman Prairie was designated a National Historic Landmark in 1990.

Huffman Prairie Flying Field Interpretive Center and Wright Memorial

Location: 2380 Memorial Road, Wright-Patterson AFB. The interpretive center features exhibits focused on the Wright brothers' development of the world's first practical airplane, their flying school and subsequent accomplishments at Wright-Patterson. Adjacent to it is the Wright Memorial. Set in a shady, twenty-seven-acre park, the memorial is a seventeen-foot-tall granite obelisk surrounded by a stone plaza. It overlooks Huffman Prairie.

Paul Laurence Dunbar House

Location: 219 North Paul Laurence Dunbar Street. Dunbar purchased this house for his mother in 1904. He completed his last work there before his death in 1906. The house was designated an Ohio state memorial in 1936 and a National Historic Landmark in 1977. Dayton History manages the house and conducts scheduled tours from Carillon Park.

Wright Cycle Co.

Location: 22 South Williams Street. This building housed the Wright brothers' fourth bicycle shop from 1895 to 1897. Their print shop was on the second floor. It was designated a National Historic Landmark in 1990.

Wright-Dunbar Visitor Center

Location: 16 South Williams Street. The national park's Wright-Dunbar Visitor Center occupies the renovated Hoover Block building at the corner of West Third and Williams. The exterior preserves the appearance of the old commercial district. The south side opens onto a plaza that leads to the bicycle shop. The facility houses an interpretive center, the Aviation Trail Parachute Museum and national park staff offices.

Wright Flyer III and Carillon Historical Park

Location: 1000 Carillon Boulevard. The original 1905 Wright Flyer III is on display in Dayton History's Wright Brothers Aviation Center at Carillon Historical Park. The center includes a replica of the bicycle shop and other exhibits. The airplane was designated a National Historic Landmark in 1990 and a Historic Mechanical Engineering Landmark in 2003.

OTHER WRIGHT SITES

Deeds Point

Location: Confluence of the Mad and Great Miami Rivers in downtown Dayton. Deeds Point is a Five Rivers Metro Park. Two bronze statues on a small plaza portray Orville twisting a bicycle inner tube box as Wilbur explains his scheme for warping wings. Website: http://metroparks.org/Parks/DeedsPoint.

Engineers Club of Dayton

Location: 110 East Monument Avenue. Edward Deeds and Charles Kettering formed the Engineers Club in 1914 as a gathering place for Dayton's growing community of scientists and engineers. Orville Wright was a member. The stately clubhouse at 110 East Monument Avenue in the center city has a full-scale Wright Flyer III sculpture on a plaza next to it and an original Wright flyer engine on display inside. Website: http://engineersclub.org.

Harry Toulmin Statue

Location: Fountain Square, Springfield. Springfield remembers Harry Toulmin, the attorney who wrote the Wright brothers' flying machine patent, with a bronze statue on Fountain Square in the center of town. It faces the historic Bushnell Building where Toulmin had his office.

National Aviation Hall of Fame

Founded in 1962, the National Aviation Hall of Fame was chartered by Congress in 1964 to honor aviators and others who helped make the United States a great nation through outstanding contributions to aviation. Wilbur and Orville were the first two enshrinees; more than two hundred have been inducted since then, including seventeen people mentioned in this book: Henry H. "Hap" Arnold (enshrined in 1967), Neil Armstrong (1979), Thomas Scott Baldwin (1964), Glenn Curtiss (1964), Octave Chanute (1963), Charles F. Kettering (1979), A. Roy Knabenshue (1965), Samuel Langley (1963), Frank Lahm (1963), Grover Loening (1969), Thomas Selfridge (1965), Glenn L. Martin (1966), Elmer and Lawrence Sperry (1973, 1981), Charles Taylor (1965) and Wilbur and Orville Wright (1962). Information and exhibits about the enshrinees are in NAHF's Learning Center, which

adjoins the National Museum of the U.S. Air Force (below). Website: http://nationalaviation.org.

National Museum of the U.S. Air Force

Location: 1100 Spaatz Street, Wright-Patterson AFB. The Wright brothers exhibit in the National Museum of the U.S. Air Force's Early Years gallery includes a replica wind tunnel, balances, charts and other tools Wilbur and Orville used in their laboratory research. The museum also displays a sample of original fabric from the 1903 Wright Flyer, a replica of the 1909 Military Flyer and an original, highly modified 1911 Model B. Website: http://www.nationalmuseum.af.mil.

Orville Wright's Laboratory Site

Location: 15 North Broadway. A small park occupies the site of Orville Wright's laboratory just north of West Third and a half block west of the bicycle shop site. The park includes a replica of the building's façade with an open doorway and a walking path that leads to a statue of Orville.

Triumph of Flight Monument (Planned)

Triumph of Flight is a planned iconic monument that would perch a three-times-life-sized sculpture of the 1905 Wright Flyer III on a tower as tall as the Statue of Liberty at the Interstate 70–75 interchange north of Dayton. Its base would include a reflecting pool and a memorial park. The nonprofit Wright Image Group, Inc. is planning and raising funds for the multimillion-dollar project. The group believes the monument, viewed by millions of motorists every year, would brand Dayton and Ohio internationally as the birthplace of aviation. Website: http://wrightmonument.org.

Woodland Cemetery

Location: 118 Woodland Avenue. Woodland Cemetery is the final resting place of the Wright brothers, Paul Laurence Dunbar and many of Dayton's most prominent citizens. Founded in 1841, the two-hundred-acre cemetery is also one of the nation's five oldest rural garden cemeteries. Its hilltop lookout, just south of downtown, offers a rare view of the Miami Valley. Website: http://woodlandcemetery.org.

Wright "B" Flyer, Inc.

Location: 10550 North Springboro Pike, Dayton-Wright Brothers Airport. The all-volunteer, not-for-profit Wright "B" Flyer, Inc. flies a modern lookalike of a 1911 Wright Model B Airplane. It also displays a nonflying close replica of a Model B. The Flying "B" has circled the Statue of Liberty, flown over the Rose Bowl and been displayed across the country and in Germany. Its non-flying replica has been displayed at major international venues, including the Farnborough International Air Show. Honorary aviator members are eligible for a free orientation hop on the one-of-a-kind airplane. Website: http://wright-b-flyer.org.

Wright Company Factory Site

Location: West Third Street at Abbey Avenue. The original Wright Company factory stands about 1.4 miles west of the Wright-Dunbar neighborhood. At this writing it was privately owned and not open to the public. In 2009, federal legislation expanded the national park's boundary to include the factory, attached buildings and surrounding acreage. The twenty-acre historic parcel adjoins a larger industrial site that's being prepared for redevelopment with a mix of public and private funds. The National Aviation Heritage Alliance is working with the National Park Service and others to fund the acquisition and restoration of the factory and redevelop three similar attached buildings with complementary activities, such as science, technology, engineering and math (STEM) education programs, sport aircraft construction, aerospace research and development or light aerospace manufacturing. Website: http://wrightfactory.org.

Wright Family Home Site and Wright Cycle Shop Site

Locations: 7 Hawthorn Street, 1127 West Third Street. The Wright Cycle Company shop and the Wright family home are now in the Henry Ford's Greenfield Village in Dearborn, Michigan. The bicycle shop site is preserved as a grassy lot between commercial buildings from the same time period. Plans to construct a memorial on the site await funding. A replica of the house's front porch and a walkway that follows the outline of the house marks the home site. An iron fence surrounding the site includes a sculpture of a bicycle leaning against it, as seen in a historic photo. A private home on the opposite side of Hawthorn was built to resemble the Wright home.

Wright State University, Paul Laurence Dunbar Library

Location: 3640 Colonel Glenn Highway, Wright State University. Established in the 1960s next to Wright-Patterson AFB, Wright State University is the namesake of the Wright brothers, and its main library is named in memory of Paul Laurence Dunbar. WSU Libraries' Special Collections and Archives includes a rich collection of Wright artifacts, papers and photographs, as well as other collections related to the Wright family, aviation history and the history of the Dayton region. A full-scale replica of the 1903 Wright Flyer hangs in the Dunbar Library's atrium. In 2014, the university was raising funds for a new building to house its archives. Website: http://libraries.wright.edu/special.

NOTES

CHAPTER 1

1. Fetters, *Trials and Triumphs*, 210, 302.
2. "United Brethren," *Dayton Daily Journal*, May 27, 1885; Fetters, *Trials and Triumphs*, 196, 236–37, 254, 255, 302, 304.
3. McFarland, *Papers*, Vol. 2, 1162; Crouch, *Bishop's Boys*, 101.
4. "Paul Laurence Dunbar: Highlights of a Life," Wright State University Libraries, http://www.libraries.wright.edu/special/dunbar/biography.php (accessed 27 March 2014).
5. Drury, *History of the City of Dayton and Montgomery County, Ohio*, 234, 571.
6. Ibid., 185–86, 190; Ohio Division of Geological Survey, Glacial Map of Ohio (Columbus: Ohio Department of Natural Resources, 2005), 2, http://www.dnr.state.oh.us/portals/10/pdf/glacial.pdf (accessed 11 April 2014).
7. This was a subtle reference to a verse from the Bible, John 1:46.
8. Pridmore and Hurd, *American Bicycle*, 10, 12, 36–40, 50.
9. Quinn Evans Architects, "Historic Structure Report: The Wright Cycle Company Building" (Ann Arbor, MI, March 31, 1999), 8; *Williams' Dayton City Directory 1890–91*, 827 and *1893–94*, 925.
10. Pridmore and Hurd, *American Bicycle*, 57; Wright Cycle Co., "Van Cleve Notes."
11. Cowan, Riordan and Barrett, *Field School Investigations*, 5–7.

CHAPTER 2

1. Cowan, Riordan and Barrett, *Field School Investigations,* 102.
2. Presumably "mite" as in something small, not a misspelling of "might."
3. Federal Aviation Administration (FAA), *Airplane Flying Handbook*, G-2, G-9.
4. Jakab, *Visions*, 121–23; W. Wright to O. Chanute, October 6, 1901, in McFarland, *Papers*, Vol. 1, 123, 127.
5. Kelly, *Wright Brothers,* 74; Jakab, *Visions,* 121–24, 128–29.
6. Fetters, *Trials and Triumphs*, 326–33.
7. Kelly, *Wright Brothers,* 81–83; McFarland, *Papers*, Vol. 1, note 5, 469–70.
8. FAA, *Airplane Flying Handbook*, 3–8.
9. Wright, "The Wright Brothers' Aeroplane," *Century*, 647–48.
10. Orville Wright, Diary, December 17, 1903.
11. McFarland, *Papers,* Vol. 1, 413.
12. Gibbs-Smith, *Invention of the Aeroplane,* 43–45; Bilstein, *Flight in America*, 13–14; Jakab, *Visions,* 26–27.

CHAPTER 3

1. *Dayton Herald*, "Farmer Saw Wrights Fly Before the World Did; He Had Faith in Them," June 17, 1909; Kelly, *Wright Brothers,* 122–23.
2. W. Wright to O. Chanute, June 21, 1904, in McFarland, *Papers*, Vol. 1, 441.
3. A.I. Root, "Our Homes," *Gleanings in Bee Culture*, January 1, 1905, 38.
4. McFarland, *Papers*, Vol. 1, 467, 472.

CHAPTER 4

1. Author eyewitness of Dusenberry crash.
2. McFarland, *Papers*, 519–21.
3. Jack Jones, "Daytonian, 88, Recalls Wrights' Test Flights," *Dayton Daily News,* September 4, 1978.

CHAPTER 5

1. Kelly, *Miracle at Kitty Hawk,* 135–37.
2. Crouch, *The Bishop's Boys*, 289–95; Gollin, *No Longer an Island*, 90–93; McFarland, *Papers*, Vol. 1, 528–29.

3. McFarland, *Papers*, Vol. 1, Appendix 4B, 654–59, originally in *La Locomotion*, April 11, 1903, 225–227; McFarland, *Papers*, Vol. 1, Appendix 4B, 659–73, originally in *L'Aérophile*, August 1903, 171–183.
4. CPI Inflation Calculator, Bureau of Labor Statistics, U.S. Department of Labor: http://www.bls.gov/data/inflation_calculator.htm (accessed April 11, 2014).
5. *Scientific American*, "Some Aeronautical Experiments," February 22, 1902; *Scientific American*, "A Successful Experiment with a Motor-Driven Aeroplane," December 26, 1903; *Scientific American*, "The Wright Aeroplane and its Fabled Performances," January 13, 1906.
6. Carl E. Myers, "A Visit to the First Show of the Aero Club of America," *Scientific American Supplement No. 1572*, February 17, 1906; W. Wright and O. Wright to Aero Club of America, March 2, 1906; Statement of the Aero Club of America, March 12, 1906; *Scientific American*, "The Wright Aeroplane and Its Performances," April 7, 1906, 291–92.
7. *Dayton Herald*, "Newest Invention of Wright Brothers Will Carry Their Aeroplane on Water," March 21, 1907; *Dayton Herald*, "Hydroplane Was Used by Wrights in Experiments," June 16, 1909.
8. *Dayton Herald*, "Guns Boom, Whistles Blow, Crowd Cheers When the Wrights Arrive," "Crowd Escorts Wrights Home," and "Hawthorn Street Is In Gala Attire," May 13, 1909.
9. *Dayton Herald*, "Wright Workshop Keeps A Grinding," May 13, 1909.
10. *Dayton Daily News*, "Gigantic are Preparations for Wright Brothers' Parade," June 3, 1909.
11. *Dayton Herald*, "Make Noise and Help Open Big Celebration," June 16, 1909.
12. *Dayton Herald*, "Celebration Program Is Completed," June 16, 1909; *Dayton Herald*, "Every Detail of Friday Parade Was Carried Out; Pageant A Big Success" and "Auto Parade Swell Event," June 19, 1909.
13. Hudson Fulton Celebration Commission, *Official Program*, pamphlet, 3; *New York Times*, "Wright Aeroplane Flies Over the Bay," September 30, 1909.

CHAPTER 6

1. Bennett, "History of the Dayton General Motors Divisions."
2. *New York Times*, "Hard to Train Men to Build Aeroplanes," April 12, 1910.
3. McFarland, *Papers*, Vol. 2, 1197–98, 1208; *Aeronautics*, "Latest Burgess-Wright Aeroplane," April 1911; O. Wright to W. Wright, May 21, 1911. Author eyewitness of the cargo flight reenactment.
4. *Dayton Daily News*, "Festival Dates are Fixed by Chamber," May 10, 1910.

5. National Park Service. "The Wright Company Factory Boundary Assessment," Washington, D.C., U.S. Government Printing Office, 2006. http://parkplanning.nps.gov/document.cfm?parkID=122&projectID=1 4539&documentID=13658 (accessed January 18, 2014).

6. H.H. Arnold, *Global Mission* (New York: Harper & Brothers, 1949), 17–19.

7. Gibson, "Population of the 100 Largest Cities," Tables 13–14.

8. Advertisement, *Dayton Daily News*, September 16, 1910; *Dayton Daily News*, "First Impressions of a Daily News reporter," September 19, 1910; *Dayton Daily News*, "Fascinated Thousands See Orville Wright Guide Flyer Over the City," September 23, 1910.

9. A.F. Barnes to L.E. Stoddard, January 18, 1912, Gertler Collection; Diary at Simms Station and flight log at Glen Head, Charles Wald Collection; *Aeronautics*, "Wright Company Starts Campaign," August 1912; *New York Times*, "Army Orders Air Craft," May 30, 1912; *New York Times*, "Flies to Save Drowning Man," October 11, 1910.

10. Curtiss and Post, *The Curtiss Aviation Book*, 8, 18–19, 24, 29–30.

11. *Dayton Journal*, "Prof. Baldwin's Airship Soars Majestically to Dizzy Heights," September 6, 1906; *Dayton Journal*, "Capt. Baldwin Makes Another Flight," September 7, 1906; *New York Times*, "Won't Drop Plan for Ocean Flight," February 28, 1914.

CHAPTER 7

1. Williams, *Wings of Opportunity*, 43; "75th Anniversary," 1–3.

2. Edwards, *Orville's Aviators*, 42, 58; Grandt, Gustafson and Cargnino, *One Small Step*, xxiii; Crouch, *Bishop's Boys*, 427–29.

3. Babson, et. al., *Remote Sensing*, 7.

4. *Dayton Daily News*, "Two Short Flights Made by Aviator," May 10, 1910.

5. *Dayton Daily News*, "Aged Bishop Wright Makes First Flight," May 26, 1910.

6. *Dayton Daily News*, "Arrange Wright Day Excursion," June 13, 1910; *Dayton Daily News*, "Train Loads Boost Wrights," June 17, 1910.

7. Walker and Wickam, *From Huffman Prairie to the Moon*, 12, 14.

8. Edwards, *Orville's Aviators*, 15–17, 21, 26, 28–29.

9. Edwards, *Orville's Aviators*, 30, 71, 131; Advertisement, "Wright Hydroaeroplane School Now Open at Glen Head, L.I.," *Aeronautics*, September 1912, 98; Advertisement, "Wright Flying School Graduates," *Aerial Age Weekly*, November 6, 1916.

10. *Aeronautics*, "Wright Training School Starts," February 1911; *Aeronautics*, "The Wright Company Has licensed the Burgess Company and Curtis," March 1911; *Augusta Chronicle*, "Augusta Has History with Wright Flight," December 17, 2003; Wright Company and Augusta Chamber of Commerce, memorandum of agreement; *Atlanta Constitution*, "Millionaire Society Men Learning to Fly in Wright Aviation School at Augusta," February 12, 1912.

11. *Aerial Age Weekly*, "Wants to Fly from Augusta, Ga., to New York," March 20, 1916; *Aviation and Aeronautical Engineering*, "The Wright-Martin Merger," August 15, 1916; *Aviation and Aeronautical Engineering*, "The Aviator—The Superman of Now," September 1, 1916; *Aerial Age Weekly*, "The Wright Flying School," March 13, 1916; Edwards, *Orville's Aviators*, 71, 131.

12. Irwin Ellis, "Aviation as a Business," *Chicago Daily Tribune*, September 20, 1911.

13. Lebow, *Cal Rodgers and the Vin Fiz*, 17–18, 20, 37, 175–77, 243–44; Smithsonian National Air and Space Museum, "Wright EX *Vin Fiz*," http://airandspace.si.edu/collections/artifact.cfm?id=A19340060000 (accessed January 14, 2014).

14. *New York Times*, "Johnstone Killed by Aeroplane Fall," November 18, 1910; McFarland, *Papers*, Vol. 2, 1007.

15. *New York Times*, "Hoxsey's Plunge to Earth," January 1, 1911.

16. *The World*, "Hoxsey and Moisant, Record-Breaking Airmen, Fall to Death Far Apart" and "Thirty-three Names on the Death Roll of Aviation," January 1, 1911.

CHAPTER 8

1. *New York Times*, "Fliers Must Pay Him, Says Wright," February 27, 1914.

2. *Dayton Journal*, "Wright Partakes of Nourishment After a Fall in His Temperature," May 30, 1912; *Dayton Evening Herald*, "Fighting Grim Death to Last, Brave Airman Gently Falls Asleep," May 30, 1912.

3. *Dayton Daily News*, "Railway Traffic to be Suspended and Bells to Toll During Funeral of Wilbur Wright" and "Stores Closed During the Funeral Service," May 31, 1912; *Dayton Journal*, "All Dayton Pays Final Tribute to World Renowned Inventive Genius," June 2, 1912; J.C. Eberhardt, "The Death of Wilbur Wright," *The Aero Club of America Bulletin*, July 1912.

CHAPTER 9

1. McFarland, *Papers*, Vol. 2, 832.

2. "Necrology," *Aeronautics*, May–June 1912, 179.

3. Advertisement, "Wright Hydroaeroplane School Now Open at Glen Head, L.I.," Aeronautics, September 1912, 98.

4. McFarland, *Papers*, Vol. 2, 1201–03; *Aeronautics*, "Front Cover," November 1912.

5. *Flight*, "The Model 'C.H.' Wright Waterplane," September 6, 1913, 978; *Aeronautics*, "New Model 'CH' Wright," July 1913, 11; Grover Loening, "The Wright Company's New Hydro-Aeroplane Model C-H," *Aircraft*, September 1913.

6. Loening, "The New Wright Aeroboat Type 'G,'" *Aeronautics*, June 15, 1914, 170.

7. McFarland, *Papers*, Vol. 2, 1200–1201; Hennessy, *United States Army Air Arm*, 71, 73, 79, 81, 99, 102.

8. Hennessy, *U.S. Army Air Arm*, 103.

9. *Aircraft*, "The Wright Incidence Indicator," September 1913, 159; *Aero*, "Angle of Attack," October 2000, http://www.boeing.com/commercial/aeromagazine/aero_12/aoa.pdf (accessed March 4, 2014); FAA, "FAA clears path for installation of angle of attack indicators," press release, February 5, 2014.

10. O. & W. Wright. "Flying Machine," U.S. Patent 1,075,533, filed February 10, 1908, and issued October 14, 1913; *Aeronautics*, "The Wright Automatic Stabilizer," January 15, 1914, 3–4; *New York Times*, "Wright Says Flying Is Fool-Proof Now," January 5, 1914; Hunsaker, *Elmer Ambrose Sperry*, 235–236.

11. The best account of Orville's feud with the Smithsonian Institution, and the source of this information, is in chapter 35 of Crouch's *Bishop's Boys*. Roach, *Wright Company*, 175, 176, 179.

12. Hennessy, *U.S. Army Air Arm*, 99, 103, 117; *Flight*, "The New Wright Biplane," November 20, 1914, 1133; Hallion, *Wright Kites*, 46–47.

13. *Aeronautics*, "Navy Opens Bids for Nine Hydros," March 15, 1915, 4; Hallion, *Wright Kites*, 55, 57.

14. Hennessy, *U.S. Army Air Arm*, 134.

15. *New York Times*, "Aeroplane Rights Sold by O. Wright," October 14, 1915.

16. Walker and Wickam, *From Huffman Prairie to the Moon*, 22; Manufacturers Aircraft Association, *Aircraft Yearbook 1919*, 33–39; CPI Inflation Calculator, Bureau of Labor Statistics, http://www.bls.gov/data/inflation_calculator.htm (accessed April 5, 2014).

CHAPTER 10

1. *Dayton Daily News*, "A Monument to the Aeroplane," February 10, 1910; Herbert A. Shaw, "Wright Museum Plans 40 Years Old," *Dayton Daily News*, September 16, 1952; *Aero Club of America Bulletin*, "The Proposed Wright Memorial," July 1912, 5; Walker and Wickam, *From Huffman Prairie to the Moon*, 23, 26, 27.
2. Chapman and Hanson, *Wright Brothers National Memorial Historic Resource Study*, 41–42, 55.
3. James V. Piersol, "A Shrine to Wrights Re-erected by Fords," *Detroit News*, July 3, 1936, and November 22 1936, available in WSU Special Collections and Archives, Box 1, MS-157; *Dayton Daily News*, "Dedication of Wright Memorial Monday Will Put Dayton in National Spotlight," August 19, 1940; Walker and Wickam, *From Huffman Prairie to the Moon*, 15.
4. Jack Jones, "Building Linked to Aviation," *Dayton Daily News*, December 27, 1972; Henry Harris, "Rescuer Sought for Orville's Lab," *Dayton Daily News*, January 24, 1974; *Dayton Journal Herald*, "Wright Lab Façade Saved," January 5, 1977.
5. Aviation Trail, Inc., "History of ATI, Inc.," http://www.aviationtrailinc.org/index_004.htm (accessed April 5, 2014).

BIBLIOGRAPHY

BOOKS

Bilstein, Roger E. *Flight in America 1900–1983: From the Wrights to the Astronauts*. Baltimore: Johns Hopkins University Press, 1984.

Crouch, Tom D. *The Bishop's Boys*. New York: W.W. Norton, 1989.

Curtiss, Glenn Hammond, and Augustus Post. *The Curtiss Aviation Book*. New York: Frederick A. Stokes Company, 1912.

Drury, A.W. *History of the City of Dayton and Montgomery County, Ohio*. Dayton, OH: S. J. Clarke, 1909.

DuFour, Howard R., and Peter J. Unitt. *Charles E. Taylor: The Wright Brothers Mechanician*. Dayton, OH: Howard R. DuFour, 1997.

Edwards, John Carver. *Orville's Aviators: Outstanding Alumni of the Wright Flying School, 1910–1916*. Jefferson, NC: McFarland & Company, 2009.

Federal Aviation Administration. *Airplane Flying Handbook*. Washington, D.C.: U.S. Government Printing Office, 2004.

Fetters, Paul R., ed. *Trials and Triumphs: A History of the Church of the United Brethren in Christ*. Huntington, IN: Church of the United Brethren in Christ, 1984.

Gibbs-Smith, Charles H. *The Invention of the Aeroplane*. New York: Taplinger, 1966.

Gollin, Alfred M. *No Longer An Island: Britain and the Wright Brothers, 1902–1909*. Stanford, CA: Stanford University Press, 1984.

Grandt, A.F. Jr., W.A. Gustafson and L.T. Cargnino. *One Small Step: The History of Aerospace Engineering at Purdue University*. Lafayette, IN: Purdue University Press, 2010.

Hennessy, Juliette. *The United States Army Air Arm, April 1861 to April 1917*. Washington, D.C.: United States Air Force, 1958. Reprint, 1985.

Howard, Fred. *Wilbur and Orville: A Biography of the Wright Brothers*. New York: Alfred A. Knopf, 1987.

Hunsaker, J.C. *Elmer Ambrose Sperry, 1860–1930: A Biographical Memoir*. Washington, D.C.: National Academy of Sciences, 1953.

Jakab, Peter. *Visions of a Flying Machine: The Wright Brothers and the Process of Invention*. Washington, D.C.: Smithsonian Institution Press, 1990.

Kelly, Fred C. *Miracle at Kitty Hawk*. New York: Farrar, Strauss & Giroux, 1951. Reprint, Cambridge: Da Capo Press, 1996.

———. *The Wright Brothers: A Biography*. New York: Harcourt, Brace & Co., 1943. Reprint, Mineola, NY: Dover, 1989.

Lebow, Eileen F. *Cal Rodgers and the Vin Fiz: The First Transcontinental Flight*. Washington, D.C.: Smithsonian Institution Press, 1989.

McFarland, Marvin W., ed. *The Papers of Wilbur and Orville Wright*. New York: McGraw-Hill, 2001. Originally published in 1953.

Miller, Ivonette Wright, ed. *Wright Reminiscences*. Wright-Patterson Air Force Base, OH: Air Force Museum Foundation, 1978.

Peters, Margaret E. *Dayton's African American Heritage*. Virginia Beach: Donning, 1995.

Pridmore, Jay, and Jim Hurd. *The American Bicycle*. Osceola, WI: Motorbooks International Publishers, 1995.

Roach, Edward J. *The Wright Company: From Invention to Industry*. Athens: Ohio University Press, 2014.

Walker, Lois E., and Shelby E. Wickam. *From Huffman Prairie to the Moon: The History of Wright-Patterson Air Force Base*. Washington, D.C.: U.S. Government Printing Office, 1986.

Williams, Julie Hedgepeth. "The 75th Anniversary of the Wright Brothers Stay in Montgomery, Alabama." Privately published, 1985.

———. *Wings of Opportunity: The Wright Brothers in Montgomery, Alabama 1910*. Montgomery, AL: NewSouth Books, 2012.

Wright, Milton. *Diaries: 1857–1917*. Dayton, OH: The Wright State University Libraries, 1999.

REPORTS, ARTICLES, CORRESPONDENCE AND OTHER PAPERS AVAILABLE ON THE INTERNET

Babson, David W., et al. *Archaeological, Geophysical, and Remote Sensing Investigations of the 1910 Wright Brothers' Hangar, Wright-Patterson Air Force Base, Ohio*. Champaign, IL: US. Army Corps of Engineers, 1998.

Bennett, Ronald W. "History of the Dayton General Motors Divisions." Privately published monograph, 2005. http://www.delcoremyhistory.com/images/GM%20divisions%20dayton%20history.PDF (accessed January 2014).

Chapman, William R., and Jill K. Hanson. *Wright Brothers National Memorial Historic Resource Study*. National Park Service, 1997. http://www.nps.gov/history/history/online_books/wrbr/hrs/hrs.htm (accessed April 25, 2014.)

Charles Wald Collection, Wright State University Libraries. http://corescholar.libraries.wright.edu/special_ms355 (accessed March 31, 2014).

Cowan, Frank L., Robert V. Riordan and N. Lee Barrett. *2003 Wright State University Field School Investigations at the Wright Cycle Shop, 33MY801, Dayton, Ohio*. Dayton, OH: Wright State University, 2003.

Gertler Collection, Seattle Museum of Flight. http://www.museumofflight.org/files/image_finding_aids/Wright-Papers.html (accessed February 20, 2014).

Gibson, Campbell. "Population of the 100 Largest Cities and Other Urban Places in the United States: 1790–1990." Population Division Working Paper No. 27, U.S. Census Bureau. http://www.census.gov/population/www/documentation/twps0027/twps0027.html (accessed November 28, 2013).

Hallion, Richard P. *The Wright Kites, Gliders, and Airplanes: A Reference Guide*. United States Air Force, 2003. http://www.afsoc.af.mil/shared/media/document/AFD-051013-002.pdf (accessed January 5, 2014).

Manufacturers Aircraft Association. *Aircraft Yearbook 1919*. Washington, D.C.: American Aviation Publications, 1919. https://archive.org/details/aerospaceyearbo00amergoog (accessed April 25, 2014).

Renstrom, Arthur George. *Wilbur & Orville Wright: A Reissue of a Chronology commemorating the Hundredth Anniversary of the Birth of Orville Wright—August 19, 1871*. Washington, D.C.: NASA, 2003. http://history.nasa.gov/monograph32.pdf (accessed November 28, 2013).

Taylor, Charles E. "My Story of the Wright Brothers." *Collier's Weekly*, December 25, 1948. http://www.unz.org/Pub/Colliers-1948dec25-00027 (accessed December 22, 2013).

Wilbur and Orville Wright Papers, Library of Congress. http://www.loc.gov/collection/wilbur-and-orville-wright-papers (accessed January 2014).

Wright Brothers Collection, Wright State University Libraries. http://corescholar.libraries.wright.edu/special_ms1 (accessed March 31, 2014).

Wright Brothers Newspapers, Dayton Metro Library. http://content.daytonmetrolibrary.org/cdm/landingpage/collection/wbnews (accessed October 7, 2013).

Wright Company and Augusta Chamber of Commerce. Memorandum of Agreement, January 12, 1911. http://www.loc.gov/resource/mwright.04178/#seq-1 (accessed 21 Feb 2014).

Wright Company Patent Litigation, Wright State University Libraries. http://corescholar.libraries.wright.edu/wright_litigation (accessed March 31, 2014).

Wright Cycle Co. "Van Cleve Notes." Privately published pamphlet. http://www.ohiomemory.org/cdm/compoundobject/collection/p267401coll36/id/23135/rec/11 (accessed December 25, 2013).

Wright, Wilbur and Orville Wright. "The Wright Brothers Aeroplane." *Century Magazine*, September 1908. http://hdl.handle.net/2027/inu.32000000493215 (accessed November 19, 2013).

INDEX

ABOUT THE AUTHOR

Timothy R. Gaffney is a writer and author who was born in Dayton in 1951 and has lived in the region most of his life. After earning a bachelor's degree from Ohio State University in Columbus in 1974, he worked for the *Piqua Daily Call*, the *Kettering-Oakwood Times* and the *Dayton Daily News*, where he was the aerospace and defense writer for twenty-one years until his retirement in 2006. He is the author of fifteen books about aviation, space, exploration and science, mainly for children and young adults. He is director of communications for the nonprofit National Aviation Heritage Alliance and a volunteer trustee of the United States Air and Trade Show Inc. and Wright "B" Flyer, Inc. His interests include aviation, photography, bicycling and hiking. He lives in Miamisburg, Ohio, with his wife, Jean. They have four grown children and two grandchildren.

Visit us at
www.historypress.net
..
This title is also available as an e-book